To Stan (Jim) my well loved "Cornhusker" Nephew.
My love always,
Mildred

A Nebraska Portfolio

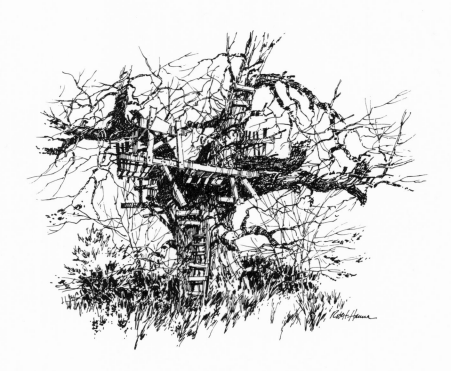

A Nebraska Portfolio

by Robert Hanna

UNIVERSITY OF NEBRASKA PRESS

LINCOLN & LONDON

1992

Publication of this book has been assisted by a grant
from the Rogers Foundation.

Printed and bound in the United States of America.
The paper in this book meets the minimum require-
ments of American National Standard for Information
Sciences — Permanence of Paper for Printed Library
Materials, ANSI Z39.48-1984.
Library of Congress Cataloging-in-Publication-Data
Hanna, Robert, 1939-
A Nebraska Portfolio / Robert Hanna.
p. cm.
ISBN 0-8032-2358-7
1. Hanna, Robert, 1939-. 2. Nebraska in art. I. Title.
NC139.H27A4 1992 741.973–dc20 92-8308 CIP

For Eloise and Richard Agee

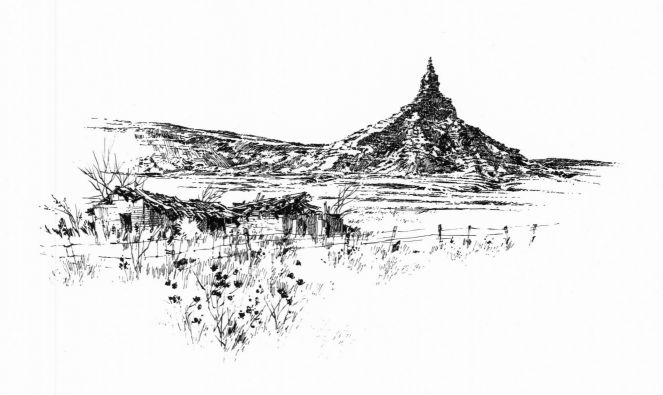

Preface

Being an artist is the best job in the world, and during the past year I've been very fortunate to have been given the opportunity to work at my real love, which is, I confess, a kind of play. I offer this book, my second from the University of Nebraska Press, to those who have given me the opportunity to enjoy myself for almost a full year—as evidence that I didn't spend all of my time nodding in the bleachers while the parade of American progress went trumpeting past. This book is the result of open-eyed wandering across Nebraska and attempting to catch the elusive spirit of our place in the world.

It's not easy trusting your instincts. Sometimes when I'm out in some small town, leaning against my old Dodge Aspen with my sketchbook open on my lap, I feel guilty—like a fisherman on a riverbank surreptitiously dangling an unbaited hook. What a good deal I've got, I think, for though artists are thought to be especially "gifted," what people may not realize is that the real gift may be that of being set apart and left alone.

For in rural Nebraska, an artist is both a curiosity and a wonder—someone to be peered at from behind the lace curtains or rubbernecked at from a passing car—but rarely to be accosted or questioned. What may be particularly disturbing about this particular artist, me, this man driving the sorriest old station wagon in the county (200,000 plus on the odometer) is that I am not only foolishly sketching some building that nobody else in the community has "paid any mind to" for thirty or forty years, but that I am also to be seen, later in the day when the light is dying, over on the empty playground shooting baskets with my own darned ball.

In addition to the places I've discovered and the lovely old buildings I've come upon, there have been discoveries of a more personal kind. One sunny summer day when I was sitting at a roadside with my back up against my be-

loved car, a big leaf fell onto my sketchbook. It was as big as my hand, heart-shaped, and as softly contoured and green as a field of winter wheat. I sniffed at its greenness and ran a finger over the tiny hairs on its surface. I held it away from me and looked at it.

It occurred to me that if I could make myself very small and could walk across its even, curving terraces, it would be like crossing a field in one of those Grant Wood paintings of the rolling farmland of Iowa. I was in a dreamy mood that day, and could almost feel my bare feet walking through the shifting grass of the leaf's warm surface and feel the breeze on my face.

When I turned it over, I found on its bottom side a tiny dwelling, shaped like an igloo, a hard green dome of cellulose within which some little creature—worm or aphid or even elf—had made a home. This little house took up no more than a thousandth of the available surface of that leaf, and around it, uninterrupted greenness rose and fell all the way to a ragged horizon. How very much alone seemed this little house in the world, and with what humility and modesty its builder had interrupted the landscape around it with his or her need for shelter.

I looked across its surface. There the little bump stood, among the drifting ribbons of summer light, its shape defying the level horizon. Here was a home built with sound engineering, dome-like for space and warmth and strength, built close to the earth to throw off the prying fingers of the wind. Who lived there? And why?

The leaf made me think of the hundreds of thousands of square miles of land on the surface of the globe, and of the hundreds of thousands of cubic feet of atmosphere towering above us. So much wildness still, in a world that we think we have tamed, with here and there a dwelling. In such a world, the ac-

complishment of enclosing a few feet of living space doesn't seem much of an accomplishment, does it? Yet we gape and marvel at crumbling Chartres, or polished Monticello, or the Sears Tower, black as a thorn in the skin of windy Chicago.

We have a right to marvel at architecture, but not only at the architecture of the art history books. Every human dwelling place is of magnificent consequence, right down to the peach-pink house trailer in a jungle of hollyhocks. For the elements are so enormous—seacoast hurricane and plains tornado, cold that can crack open a steel engine block like a walnut, heat and drought that can kill thousands of acres of plants. That any kind of creature can find a little shelter in all that violence is, simply, wonderful.

My book of drawings and watercolors is a celebration of spaces—little spaces, really. Set down a towering county courthouse in the middle of a wide Nebraska horizon, and even government looks mighty small. In making these pictures, I have placed myself and my old station wagon within the sphere of influence of the buildings. I have felt the coolness of their shadows and the warmth of the sunlight glancing off their flanks. I have breathed the dank air pouring out of their dark and empty windows. In short, I have drawn and painted these pictures from inside the world of the buildings and places they represent. And since my Dodge was there with me, I have included it in many of the scenes.

During my year of wandering—my *Wanderjahr*, as my German forebears would have called it—I've sketched a number of places that have special meaning for me. For example, among these pages you'll find Brownie's Barbershop in my hometown, Grand Island. The tattooed Brownie swore like a sailor, and because of this his was the one barbershop that parents sent their

children to rather than accompany them there. He may have been offensive but he gave a good haircut, and life is full of compromises. Brownie died in 1985 and his noisy days in the once glorious Michelson Building are little more today than a wisp of hair blowing across a cracked and broken floor.

I traveled more than ten thousand miles during my year on the road, perhaps even fifteen thousand. When the weather was bad, I sat in my white chariot and drew from what I could make out through the steamy windshield. In Omaha, I spent many days to document only a portion of the city, whereas in Bushnell, on the other end of the state, one sketch captured most of the town.

My traveling companions on the road included my drawing and painting gear, my old car, and my basketball. Every town in Nebraska has, somewhere in it, a hoop fastened onto the front of a garage or in the public park. Wherever I stopped, I would cage a few, so that at the end of my wandering I can say with some assurance that I have shot more baskets in more towns in Nebraska than any other person, ever. I even shot baskets by the light of the moon in the Nebraska National Forest, near Halsey, where the backboards are shaped like pine trees. You can tell if a town has a reputation for supporting basketball if it has real nets, not those silly chain nets that never wear out but can't muster up the sound of a swish. Worse yet is a basket without a net.

At Chimney Rock, one can't help but think of lines of covered wagons creaking along the Oregon Trail and those stories of the army using the spire of rock as a target for artillery practice. In my drawing (no. 72) I included the collapsed carcass of an early plains homestead. Our state brochures promoting tourism never seem to get this old building into their photographs,

probably because it doesn't say a whole lot for economic development. It represents economic development in reverse. Oddly, the form of this old structure echoes the form of Chimney Rock, as you'll see.

To draw them, it isn't necessary to get close to Chimney Rock, but it is necessary to get close to Carhenge (no. 4) near Alliance. Though Chimney Rock is a natural wonder and Carhenge is a built wonder, I had the same sense of being in the presence of something timeless.

In Nelson, Nebraska, I came upon a surprise: expressive faces carved into the arches of a building built in 1899 (nos. 129, 155). Who were these people—friends or associates of the building owner? And why does the one face have a winking eye? Whatever the joke, the laughter has been silent for nearly a century.

The Nebraska State Capitol, completed in 1932, is a wonder of twentieth-century architecture. Rising above the level plains, it is visible for thirty miles. In a recent book on architectural design, our state capitol was compared to the cathedral at Chartres! Weather permitting, I sometimes have coffee in the courtyard with fellow architect and dreamer Charles Nelson. The walls of this courtyard frame a different piece of the Nebraska sky every day, as we try to feel the spirit of Bertram Goodhue, the capitol's architect.

It's an extremely difficult building to draw. Even Goodhue never attempted an architectural rendering. Simply sketching Lee Lawrie's carved pylon figures (no. 6) was the easiest way of approaching this magnificent and intimidating structure.

There are a number of barns in this book, round barns, tall barns, barns with fancy cupolas, barns leaning a little, barns falling down. Some of these

have reached a hundred years of age, and it would be good if the president of the United States would write *them* a letter of congratulation! For there's nothing quite so magnificent as a barn, with its long, self-effacing history—a golden cornucopia from which hundreds of thousands of bushels have spilled.

Some of them are architectural wonders. There's a round barn in Webster County that is 130 feet in diameter and 65 feet high (no. 137). The red and white Alexander Thom barn north of North Bend on highway 79 doesn't have a nail in it; wooden pegs keep it together (no. 7). Harvey Ehlers built a barn near Bennet that is 90 feet in diameter and has a roof rising five stories above the second floor, the whole thing held together by a central silo (no. 133). How I love them, with their silent, cavernous spaces sprinkled with light, the pigeons cooing in the rafters, those hardworking old ladders whose rungs are worn thin in the middle. Though the world may have plenty of paintings and sketches and photographs of old barns, artists will always be drawn to them, for they are irresistible.

Nebraska has many bandstands, and to me they represent the memory of small towns as they once were, when there were Sunday picnics on the square, Fourth of July celebrations, local and national politicians standing in their shade to harangue the stubborn citizenry. I have stood in hushed bandstands in Humboldt and Table Rock and Broken Bow, feeling the whole town surround me. I drew the bandstand in Polk (no. 8) as a tribute to Norris Alfred, retired editor of the *Polk Progress*, which shut down in 1989. The *Polk Progress*, a journal of irascibility and common sense, once reached a total of nine hundred subscribers in forty-five states. Its guiding motto was "Slower is better."

[xii]

Advertising signs are a part of history, too, and one I chose to include in this collection was from the Golden Hotel in O'Neill. (The Golden also has a barber shop with a barber pole, by the way. Even the familiar red and white striped barber pole is vanishing from the streets of America.) On my last trip through O'Neill, I was sad to see the Golden's sign replaced by a new one that said, merely and emphatically, Hotel, as if it no longer mattered that a bed for the night be golden.

I've painted a fading Dr. Pepper sign in Jackson and Phil's Tire Shop in Pender (nos. 128, 127). Phil has run his wayside tire shop since 1927, and the signs appear to be holding the building together. I've also included several representative movie marquees. Some of the most decorative are those for the New Moon in Neligh, the Midwest in Scottsbluff, and the Elite Theatre in Crawford. There are many old movie houses across Nebraska, and too many of them are announcing the sad film called "Closed."

In a way, I feel somewhat responsible for the fate of some of the architectural landmarks that have vanished during the past few years. In my first book, *Sketches of Nebraska*, I may have started something. I may well have looked too hard and long at some of my subjects, perhaps loosening the nails with my gaze and letting a prying finger of wind in under the one length of clapboard holding a collapsing building together. For many of those buildings are gone, some of them burned for practice by the volunteer fire brigade, some burned by accident. The ashes are just the same either way, soggy and black and sprinkled with rusty nails, but with a little grass coming through. What ever happened to the elevators at Doniphan and Columbus and to Willa Cather's railroad depot at Wymore, called Waymore in *My Ántonia*? Where is the drive-in at Funk, the old railroad bridge near Greenwood, the railroad

[xiii]

watchtower at Grand Island, the stand of cottonwoods at Ceresco? They're in my drawings, but gone to the passerby.

Have you ever noticed how a city hall can tell you what a town thinks of itself. The glorious old ones, with heavy domes and elaborate staircases and arched entryways, convey an old-fashioned respect for the institutions of government. The new courthouses, standing like bunkers on the sites of grand old buildings, speak of expedience. There, government is looking for a low profile.

Among the interesting courthouses in the state are those at Grand Island, Tecumseh, Beatrice, and Plattsmouth. The architect for the magnificent Beatrice courthouse—one hundred years old in 1991—was Louis Curtiss, whose fame somehow slipped from his hands. He lies in an unmarked grave somewhere in Kansas City.

Scattered across the state are many country schools, many with classic, picture-postcard design, and a number of them still in use. Most of them, though, have been reduced to relics, surrounded by weeds and with a few pigeons bursting from the broken windows like the remnants of school prayer.

And churches—so many churches, from the massive stone cathedrals of wealthy Omaha to the tiny clapboard houses of God at places like the Santee Indian Reservation.

The ballparks are vanishing, too. Every small town once had a ballpark, maybe with a sign in the middle of the busiest street intersection saying who was playing that night. Remember Sinatra's lament: "There used to be a ballpark *right here!*" We puzzle over what ever happened to Lincoln's Sherman Field, where Porky Oltman and his 1955 Lincoln Optimists made it to the National Junior Legion Finals with only eleven players left. Sometimes I still

[xiv]

feel like I'm somewhere out there in center field, far beyond the infield lights, trying to see a ball whistling down toward me out of the ink-black sky.

I learned early that I wasn't going to make the majors, but there is a lot to be said for staying off the field and looking on. In a way, with my drawing and painting I'm still busy scratching my name in the bleachers, even though the grass has grown tall on the infield and the green-painted wood fence and grandstand have been broken up for kindling and the morning glories have taken over the backstop.

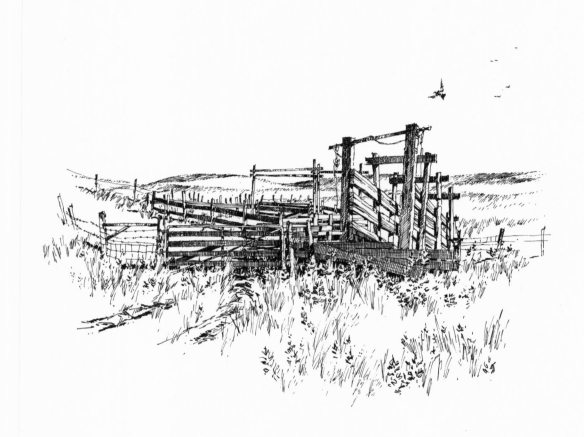

Illustrations

A Nebraska Portfolio

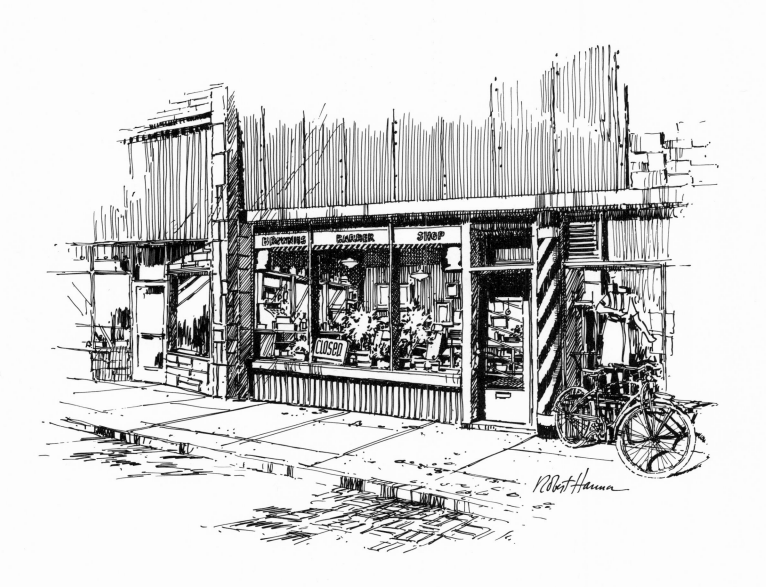

1. Brownie's Barber Shop, Third and Pine Street, Grand Island.

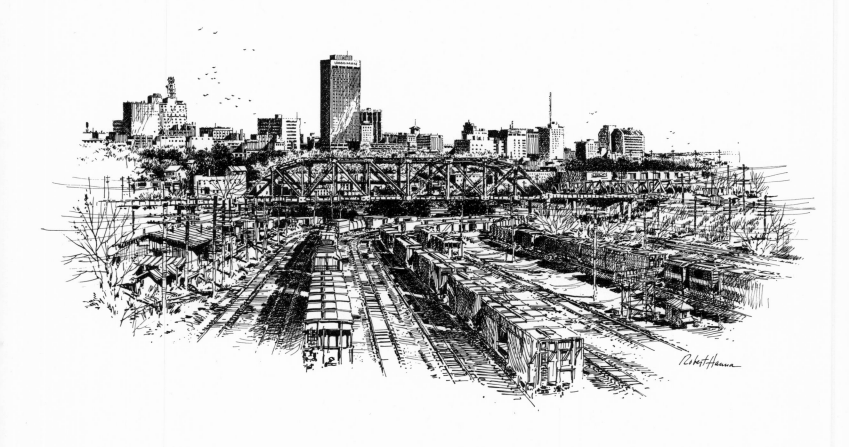

2. View of Omaha and the Martha Street Bridge, built 1931, demolished 1990.

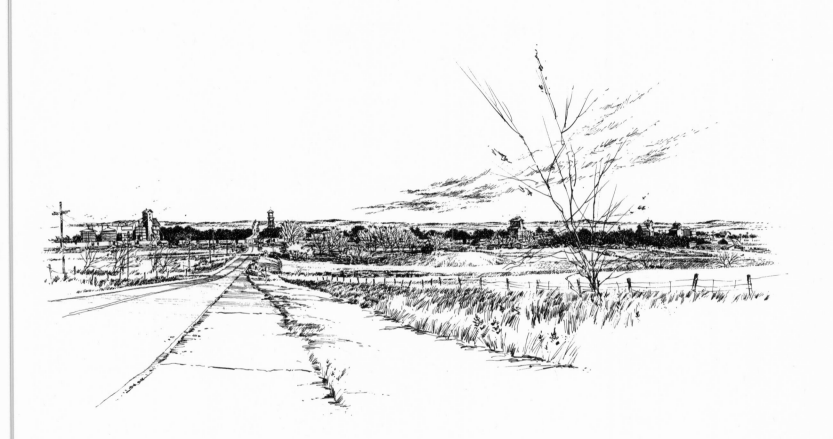

3. View of Bushnell.

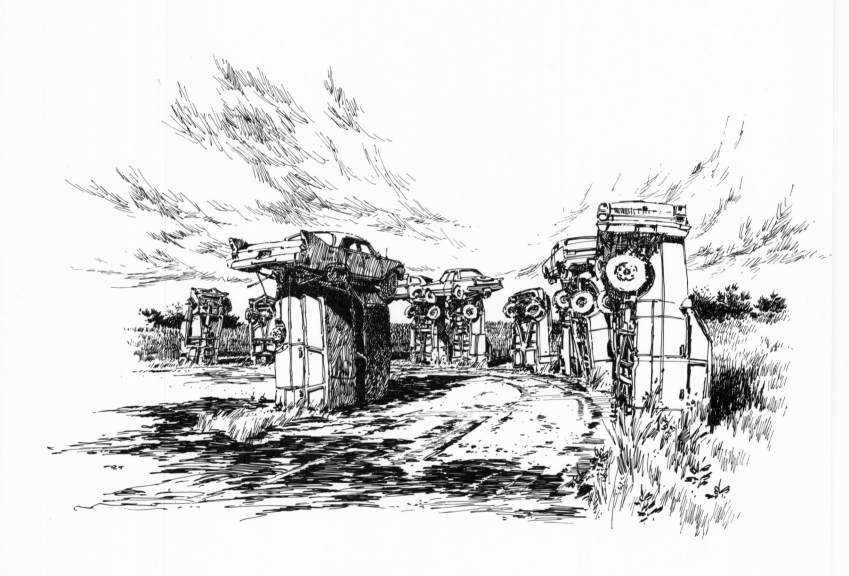

4. Carhenge, created 1987 by Jim Reinders, on Highway 385 near Alliance.

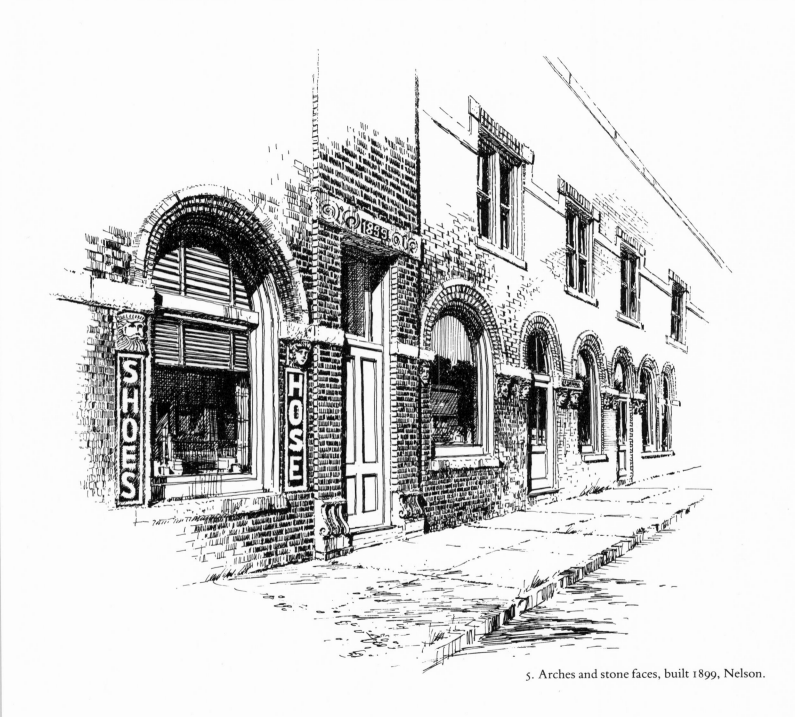

5. Arches and stone faces, built 1899, Nelson.

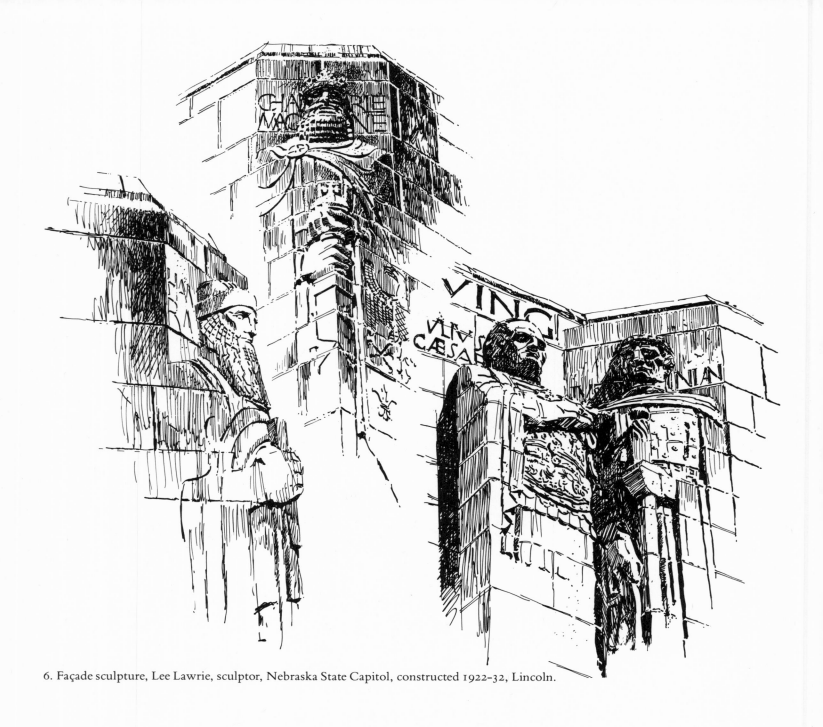

6. Façade sculpture, Lee Lawrie, sculptor, Nebraska State Capitol, constructed 1922–32, Lincoln.

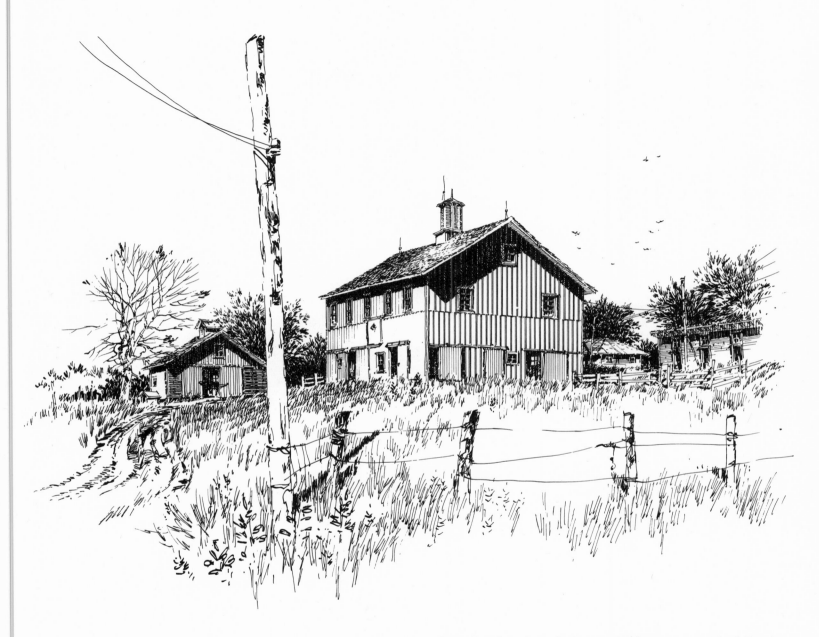

7. Alexander Thom barn, built 1888, Highway 79 near North Bend.

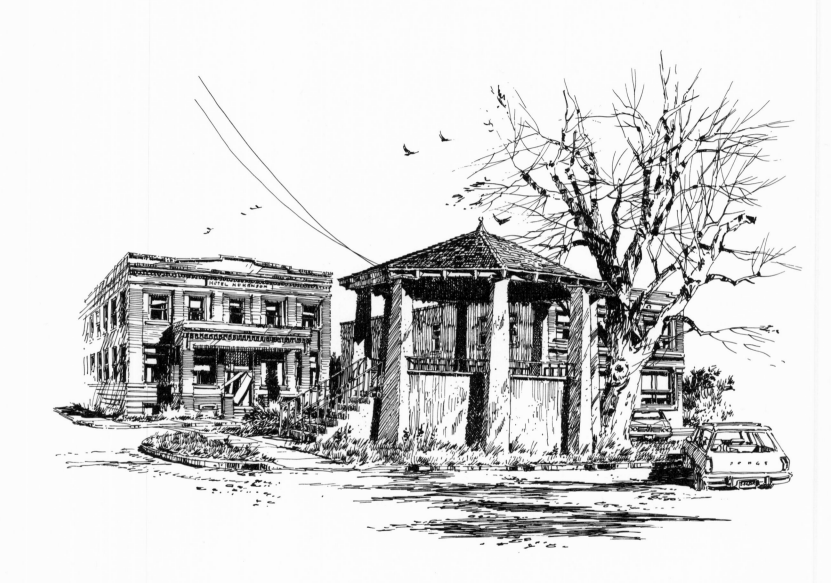

8. Hotel Hokenson (built 1916, demolished 1990) and bandstand, Polk.

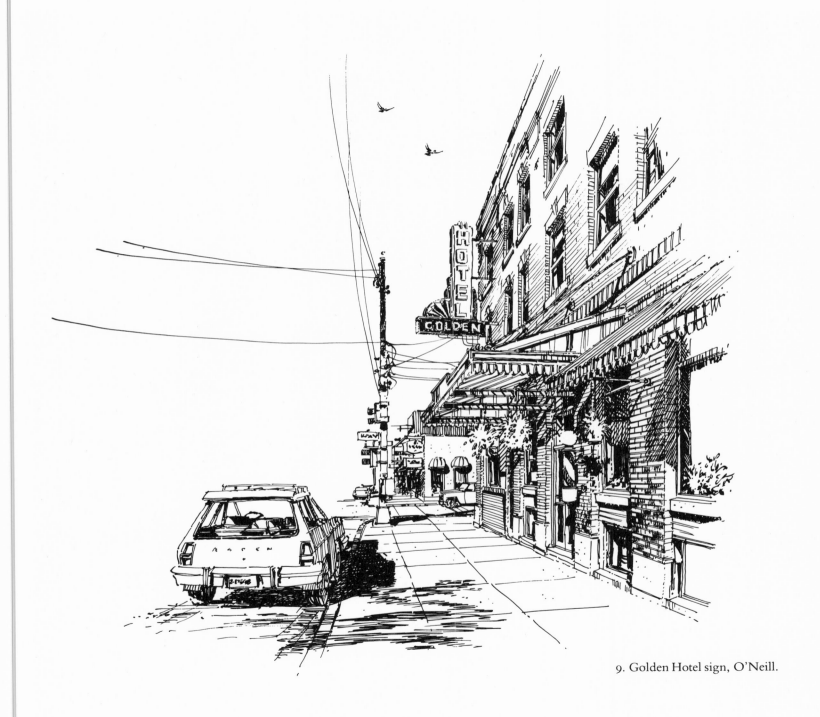

9. Golden Hotel sign, O'Neill.

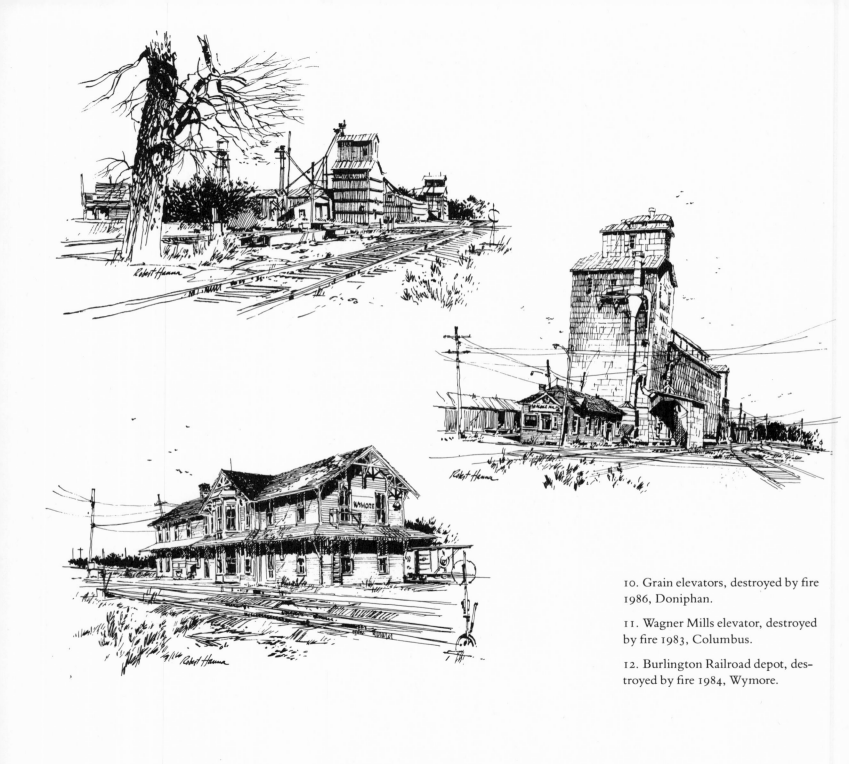

10. Grain elevators, destroyed by fire 1986, Doniphan.

11. Wagner Mills elevator, destroyed by fire 1983, Columbus.

12. Burlington Railroad depot, destroyed by fire 1984, Wymore.

13. Country bridge over the Burlington Railroad, Highway 6 near Greenwood.

14. Green Valley Café, razed 1987, Highway 6, Funk.

15. Union Pacific and Burlington watchtower, razed 1983, Grand Island.

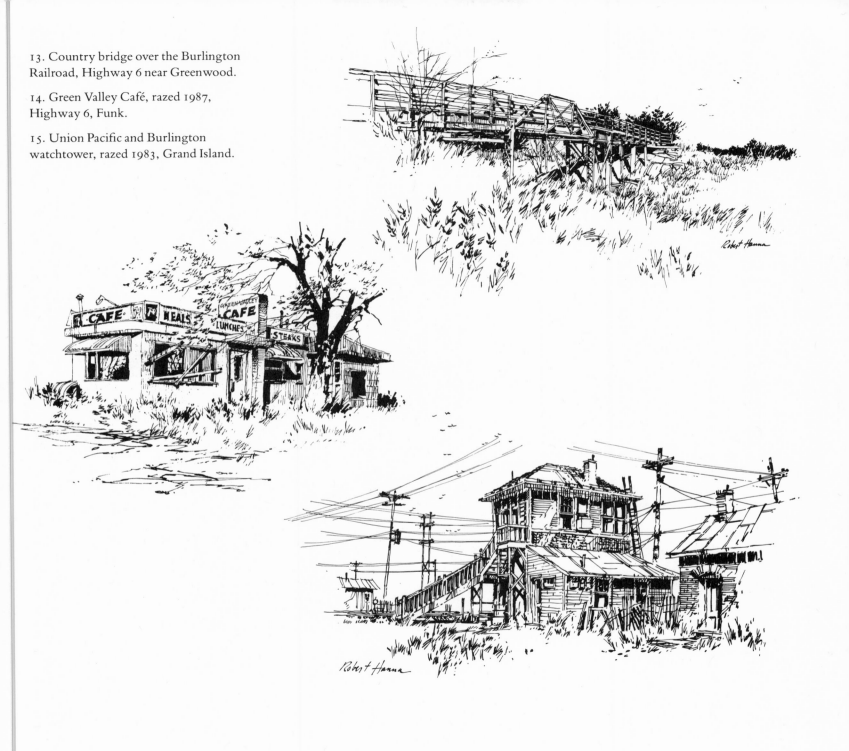

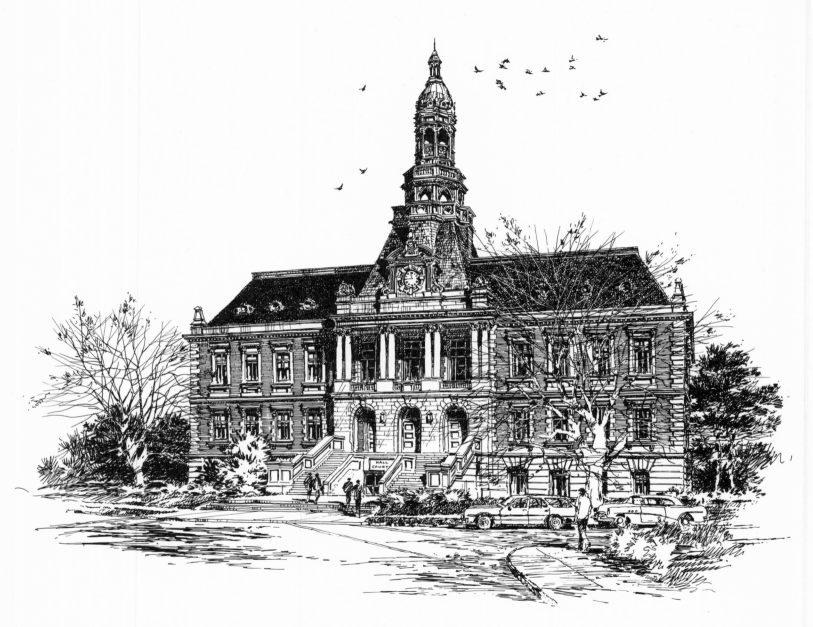

16. Hall County courthouse, completed 1904, Grand Island. Thomas Rogers Kimball, architect.

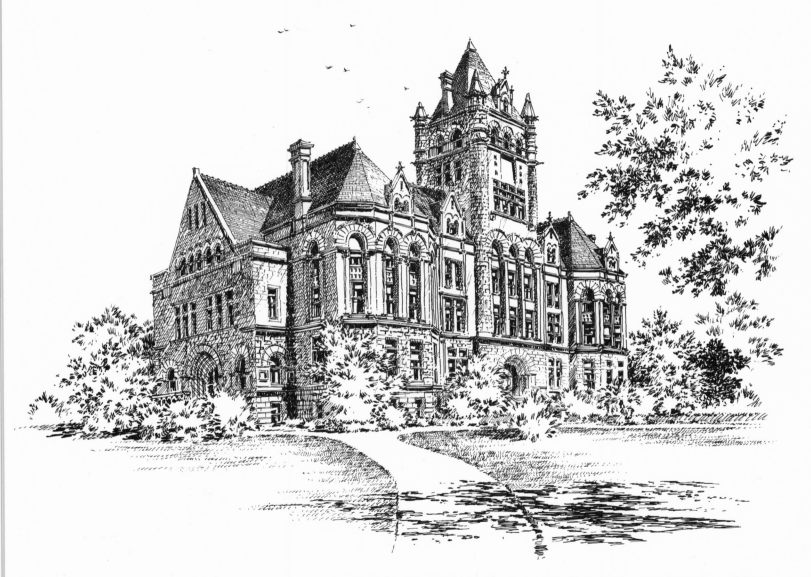

17. Gage County courthouse, built 1890-91, Beatrice. Gunn and Curtiss, architects.

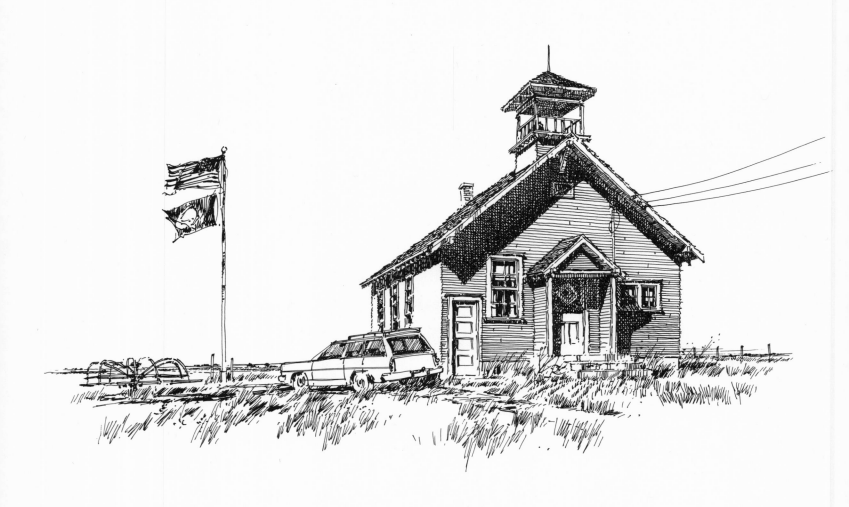

18. Country schoolhouse near Gordon.

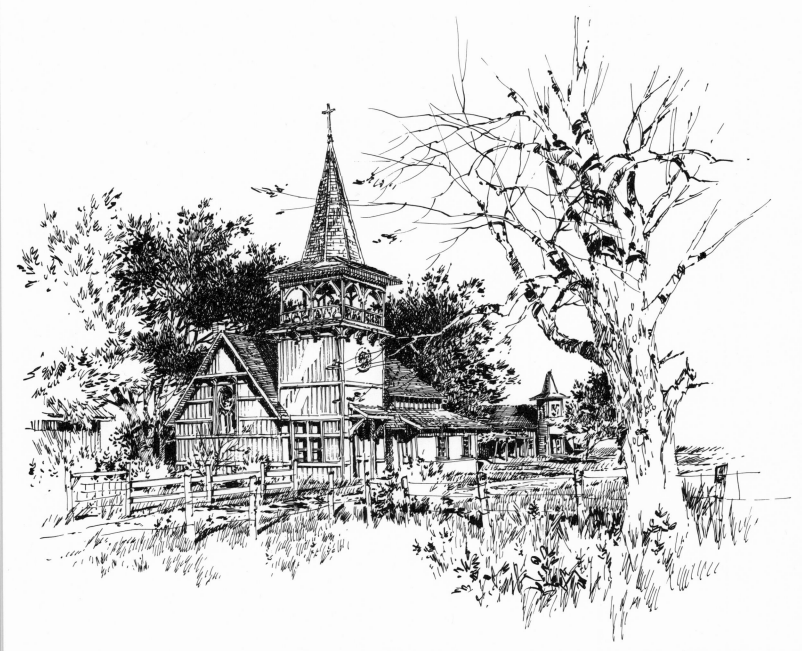

19. Pilgrim Congregational Church, constructed 1870-71. Santee (Santee Indian Reservation).

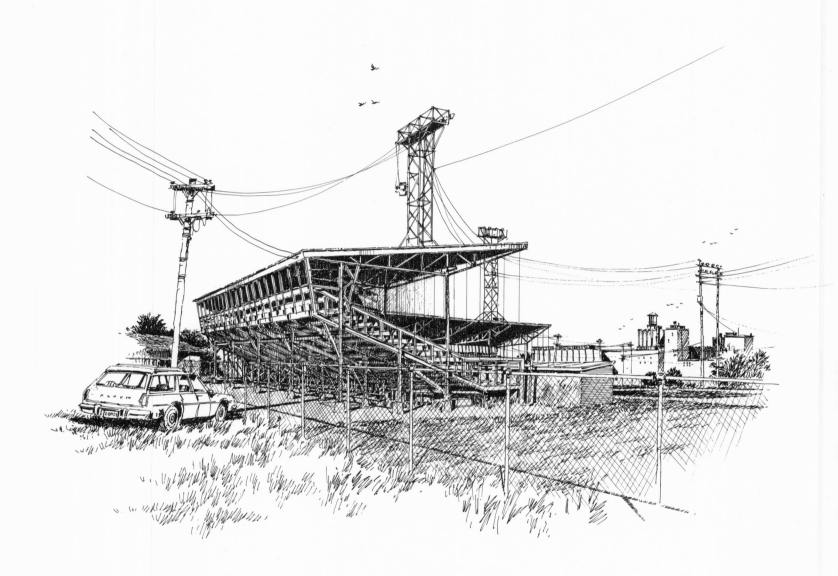

20. Sherman Field ballpark, Lincoln.

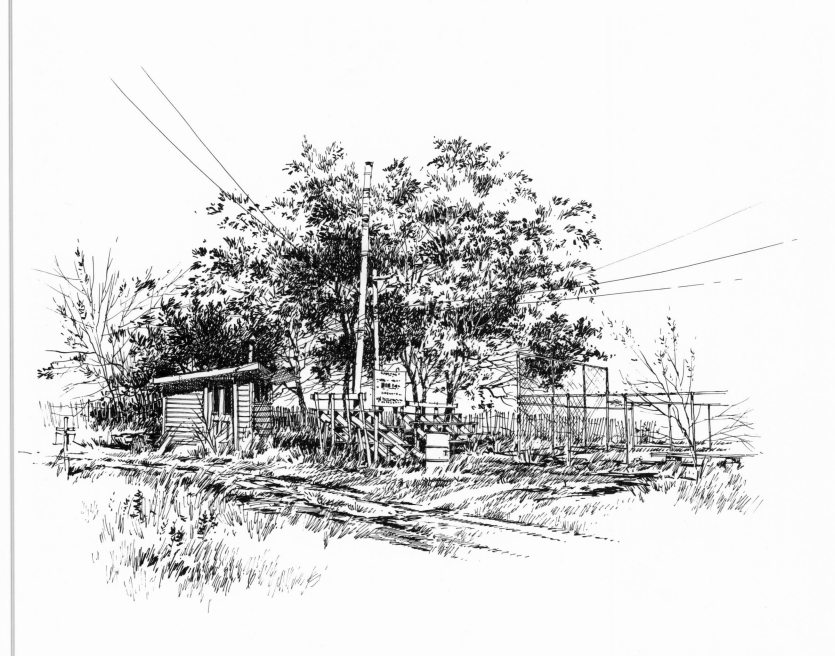

21. Ballpark, Meadow Grove.

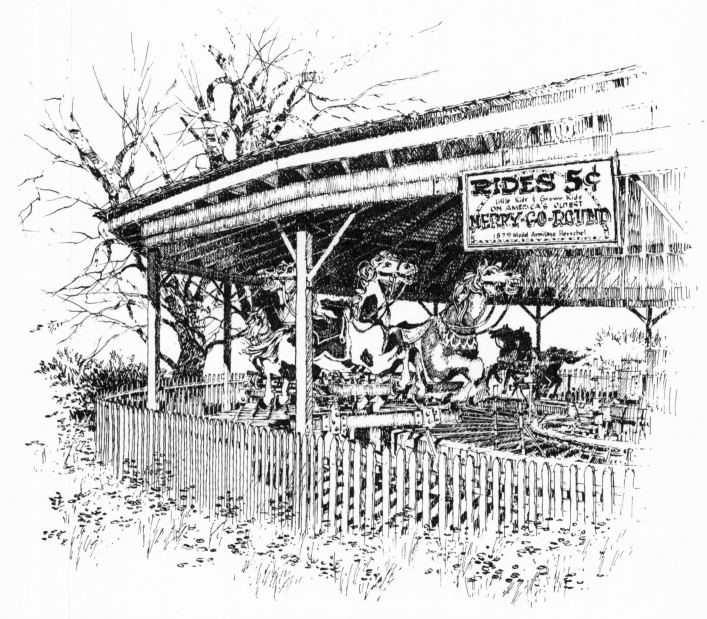

22. Merry-Go-Round, oldest steam carousel in the USA, Harold Warp's Pioneer Village, Minden.

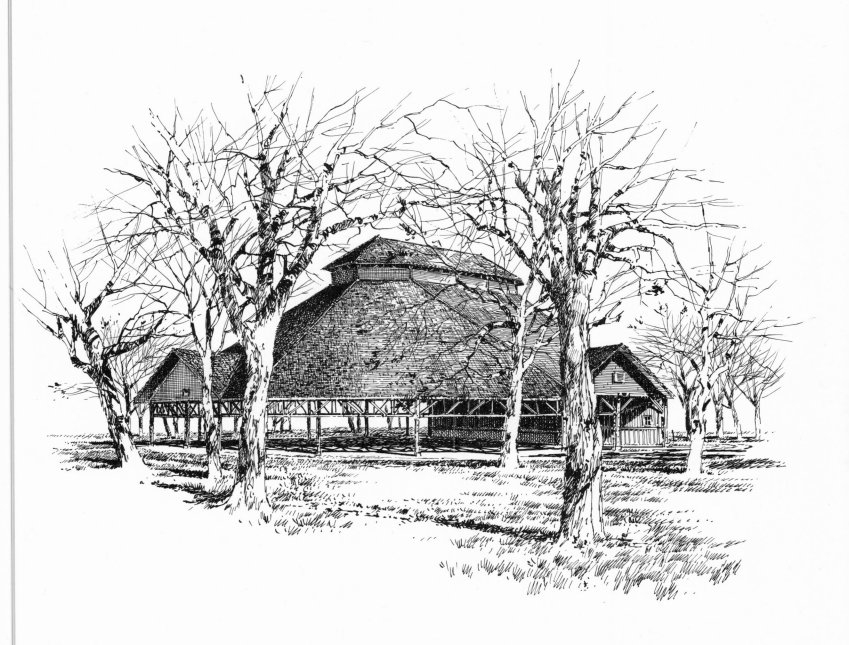

23. Chatauqua pavilion, built 1907, seats 3500 people, Hastings.

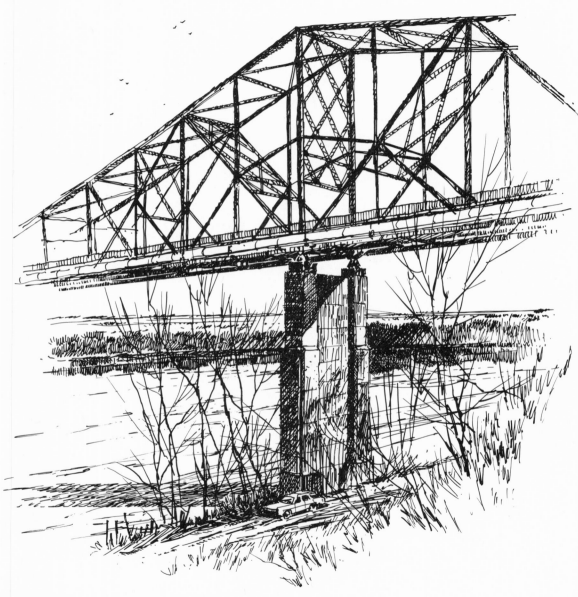

24. Bridge over the Missouri River, Plattsmouth, built 1929.

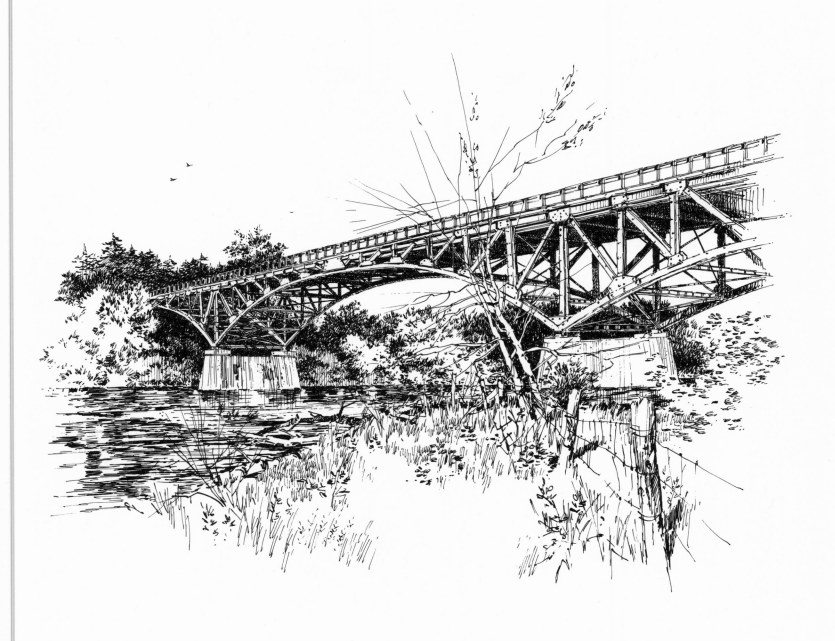

25. Bryan Bridge, built 1932, spanning the Niobrara River near Valentine.

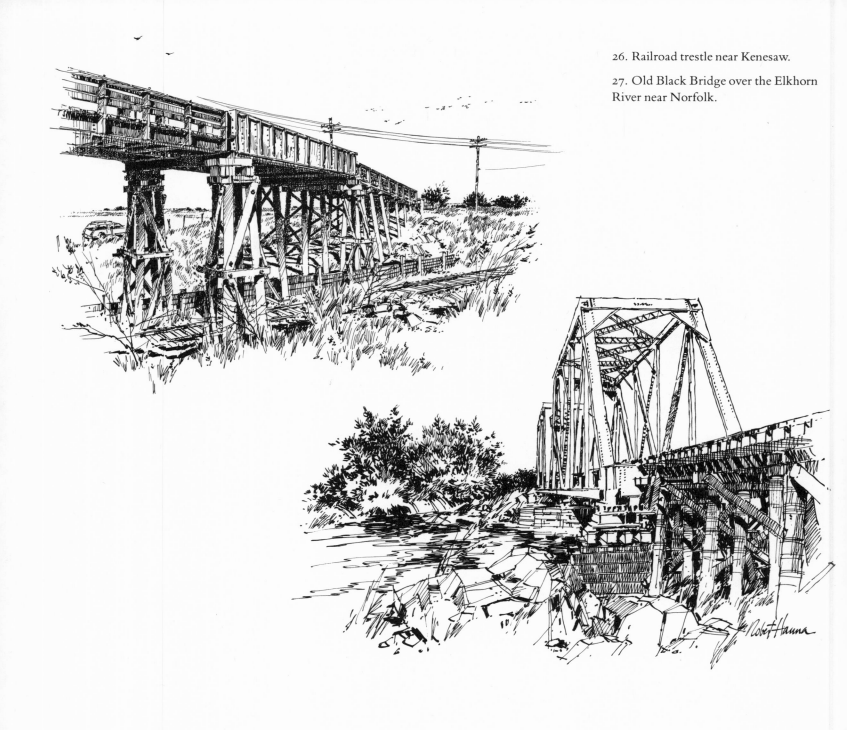

26. Railroad trestle near Kenesaw.

27. Old Black Bridge over the Elkhorn River near Norfolk.

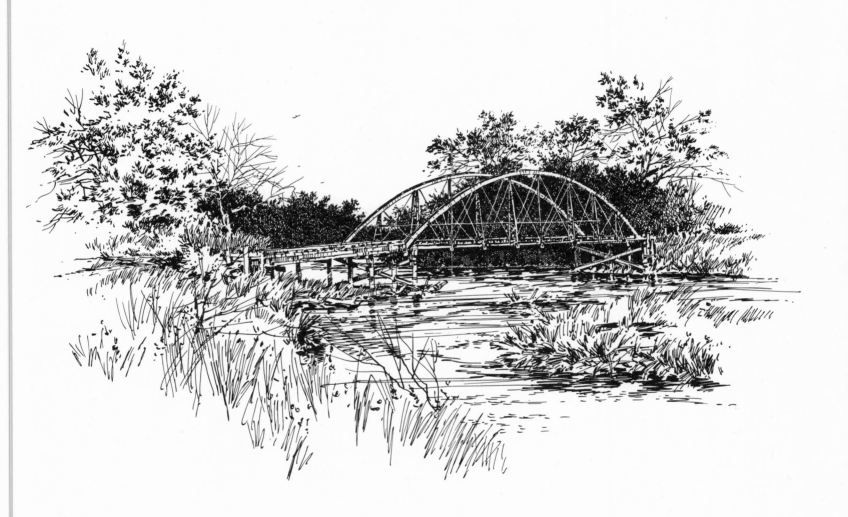

28. Bridge over the Elkhorn River east of Clearwater, built 1959, now abandoned.

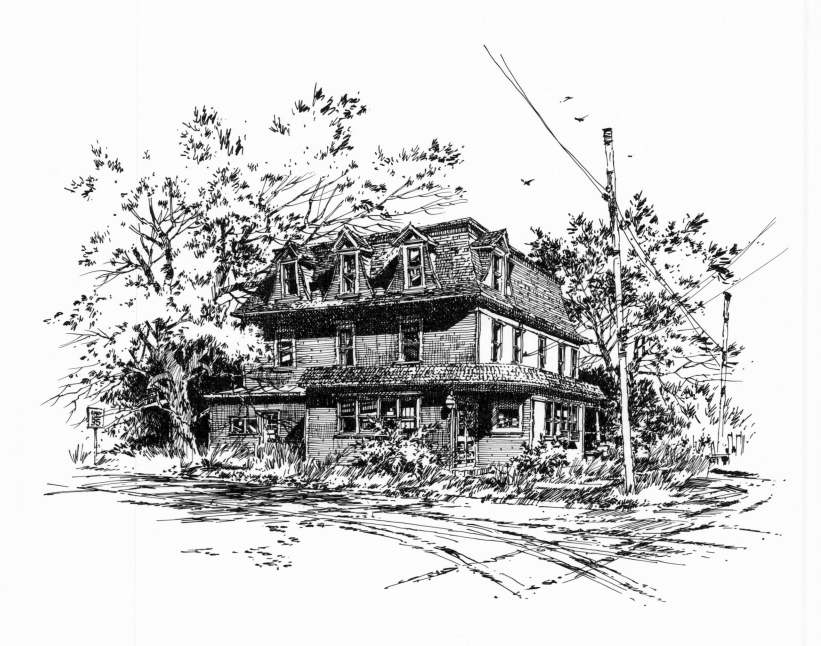

29. The Pavilion Hotel, built 1887, Taylor.

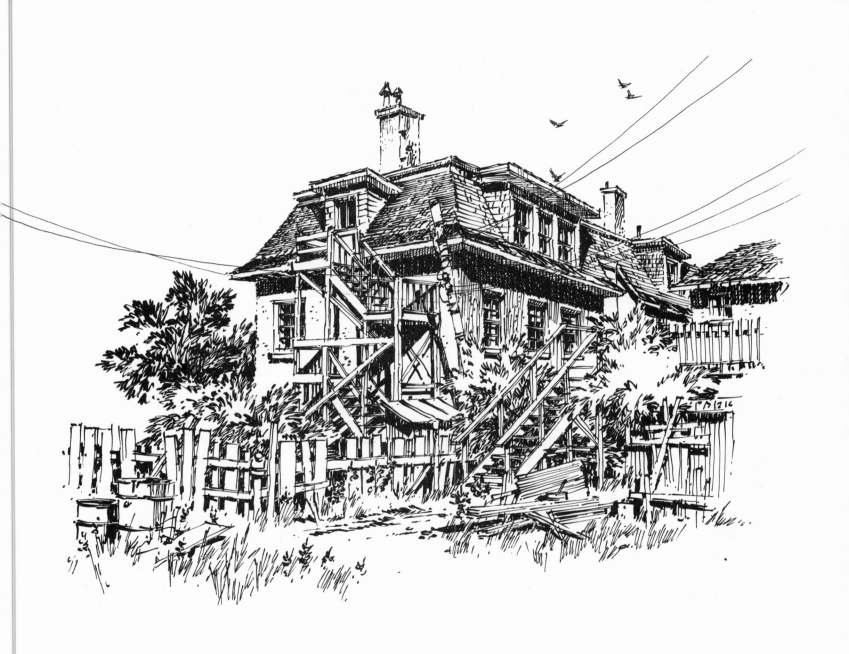

30. Hotel DeFair, built 1898, on Highway 2 and Main Street, Hyannis.

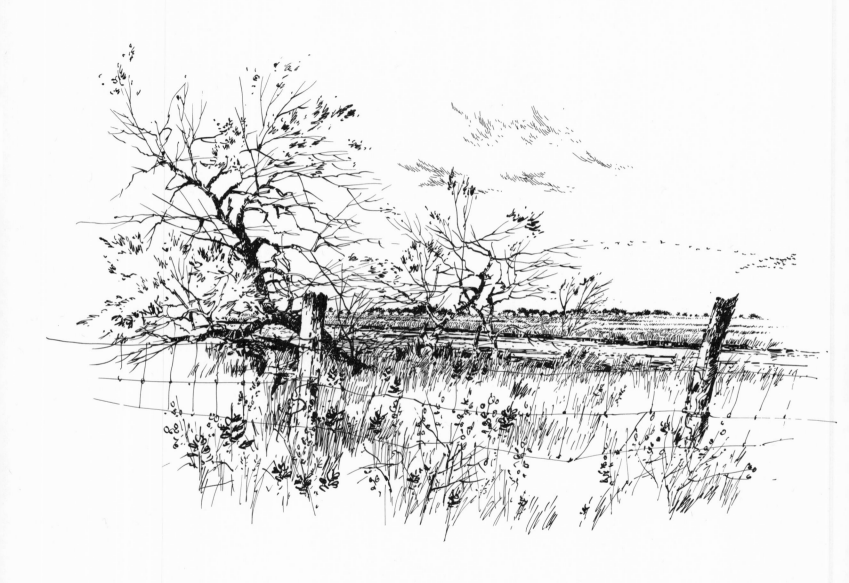

31. View of haystacks and North Loup River near Brownlee.

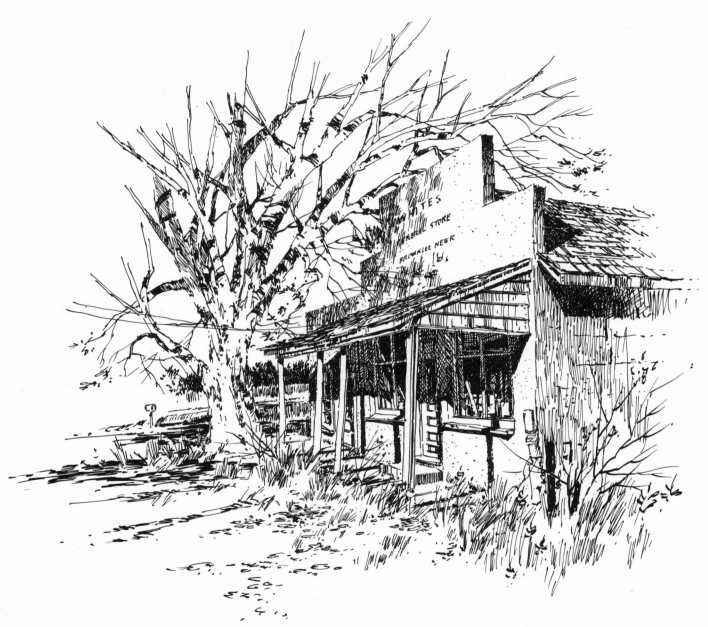

32. Whites General Store, Brownlee.

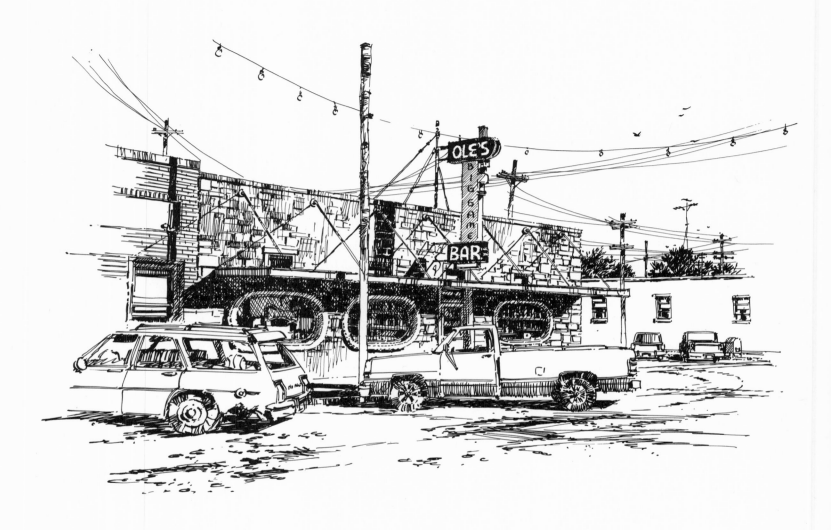

33. Ole's Big Game Bar, established 1933 by Rosser O. Herstedt, Paxton.

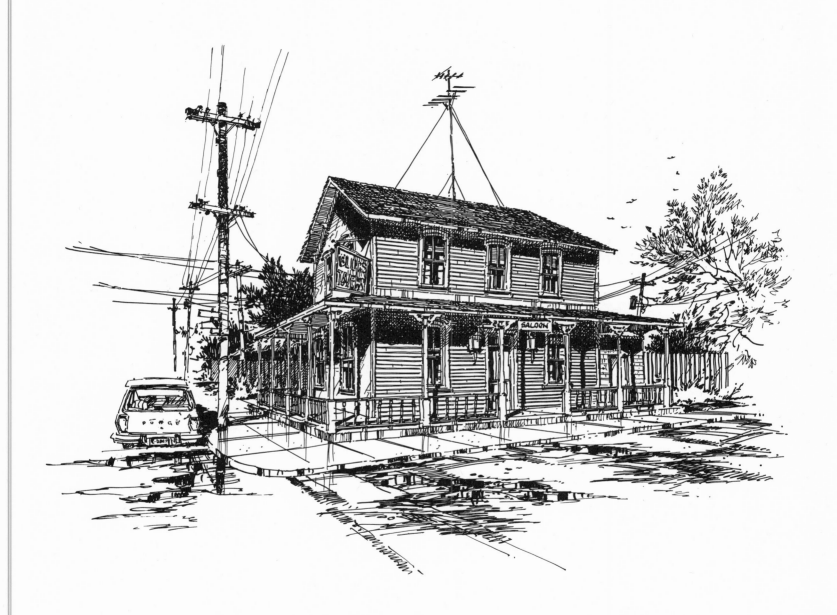

34. Bucher Saloon (Glur's Tavern), built 1876, Columbus.

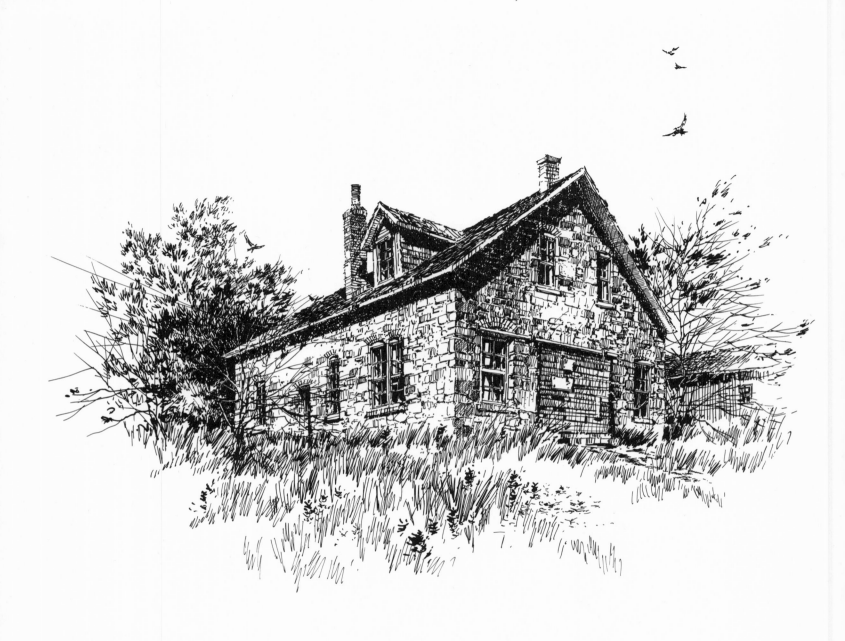

35. Stone blacksmith shop (Jefferson County Historical Museum), built 1900, Steele City.

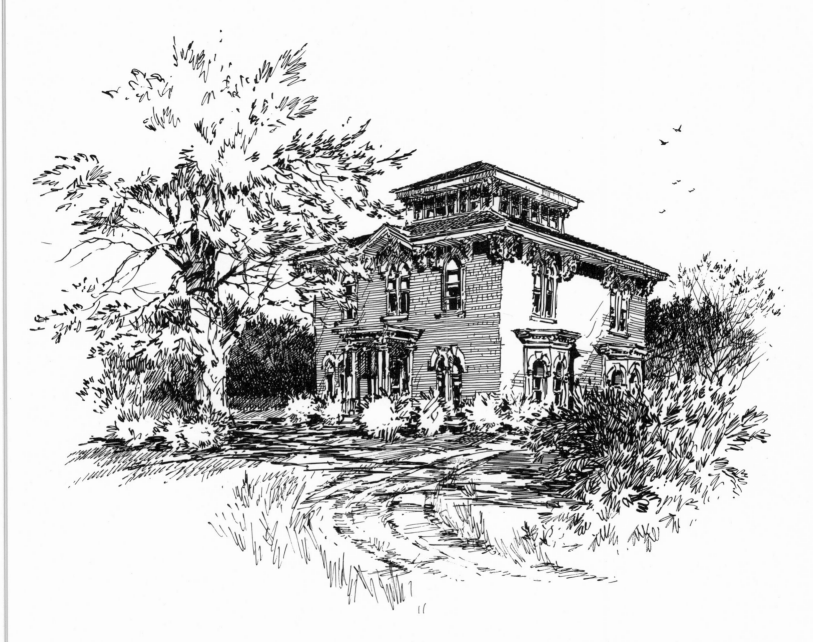

36. The Muir House, built 1868, Brownville.

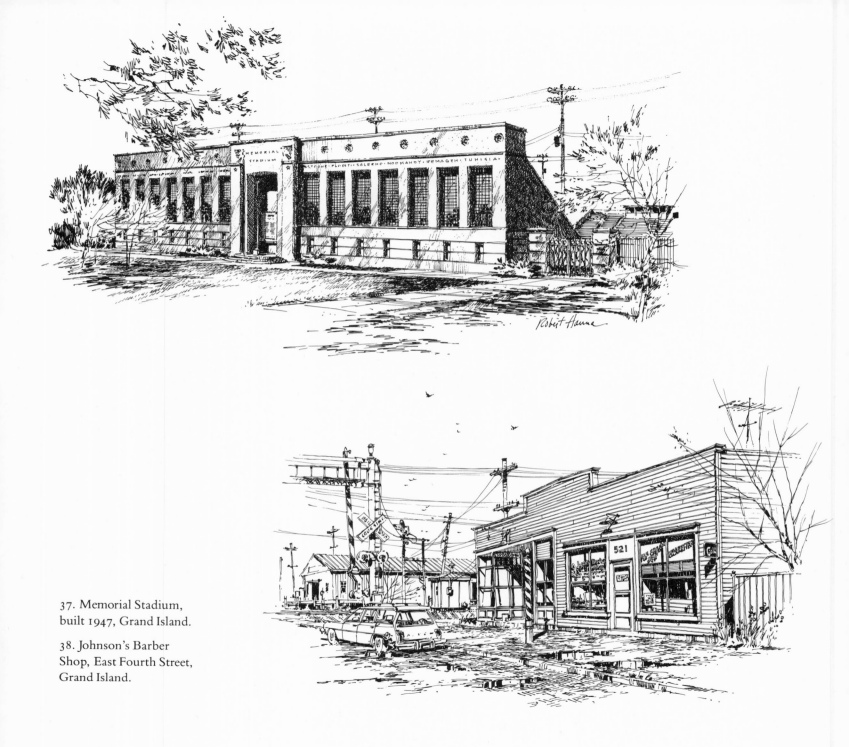

37. Memorial Stadium,
built 1947, Grand Island.

38. Johnson's Barber
Shop, East Fourth Street,
Grand Island.

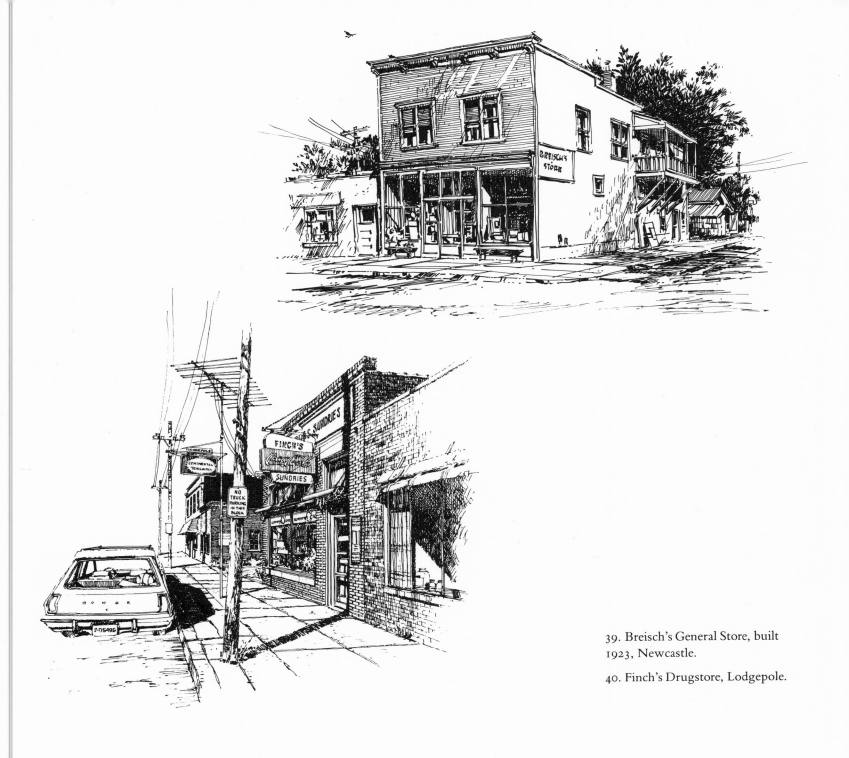

39. Breisch's General Store, built
1923, Newcastle.

40. Finch's Drugstore, Lodgepole.

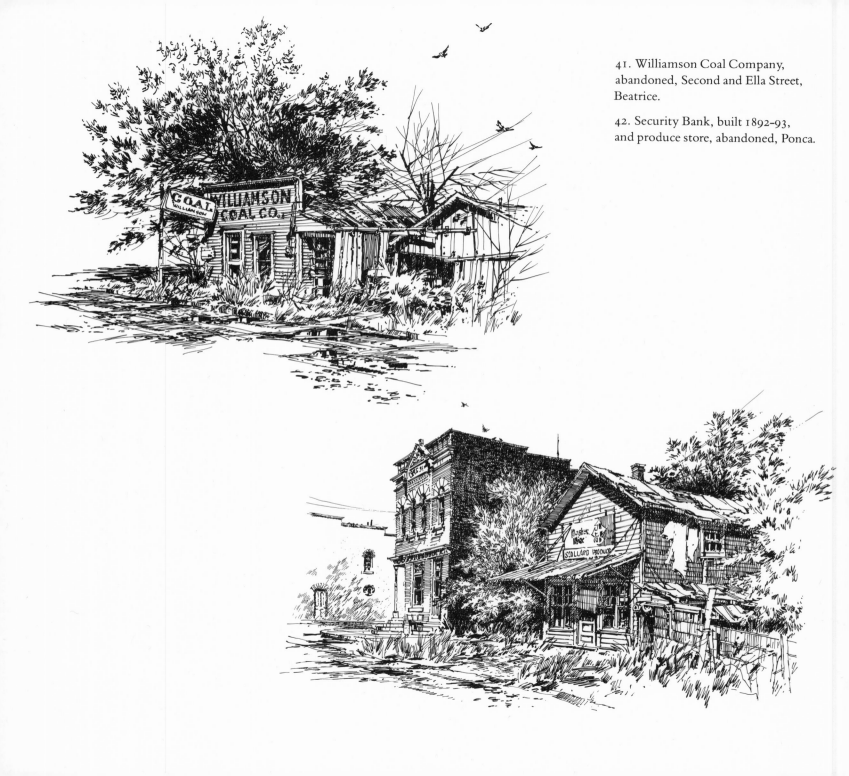

41. Williamson Coal Company,
abandoned, Second and Ella Street,
Beatrice.

42. Security Bank, built 1892-93,
and produce store, abandoned, Ponca.

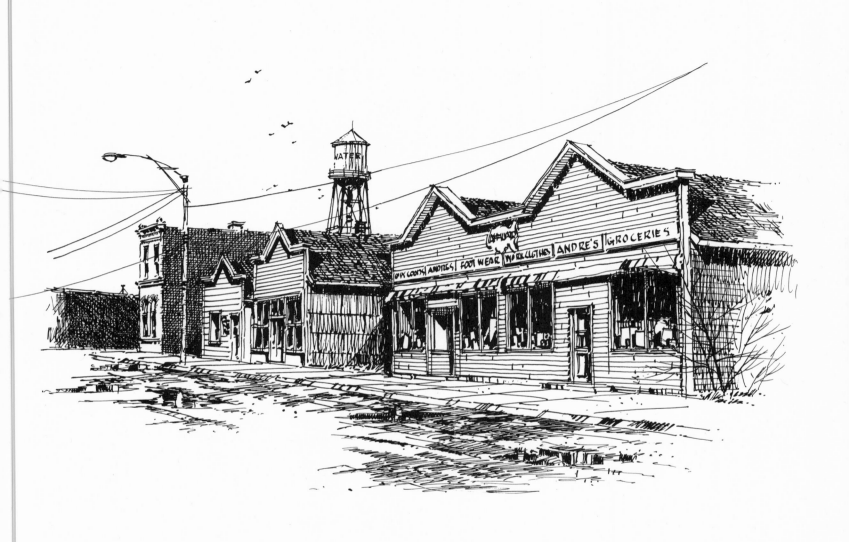

43. Citizens State Bank, store fronts, water tower and Andre's Store (built early 1900s), Petersburg.

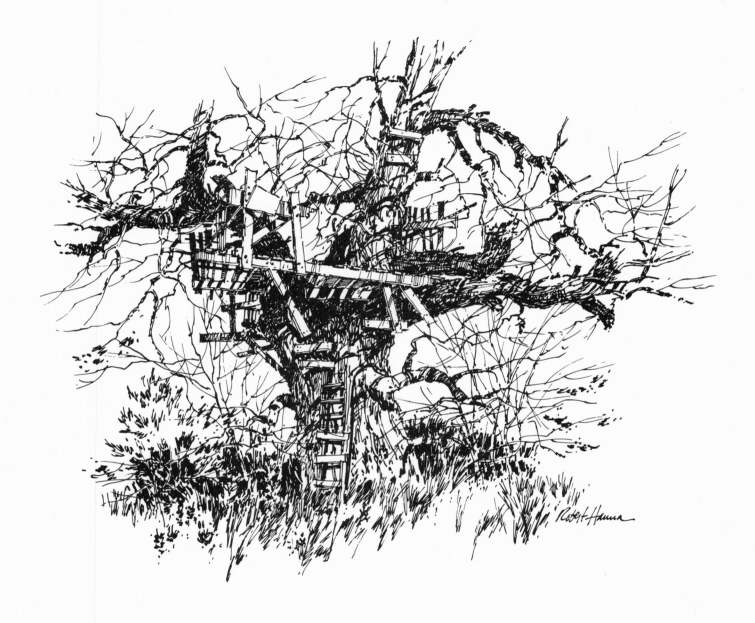

44. Cottonwood and tree house, Lancaster County.

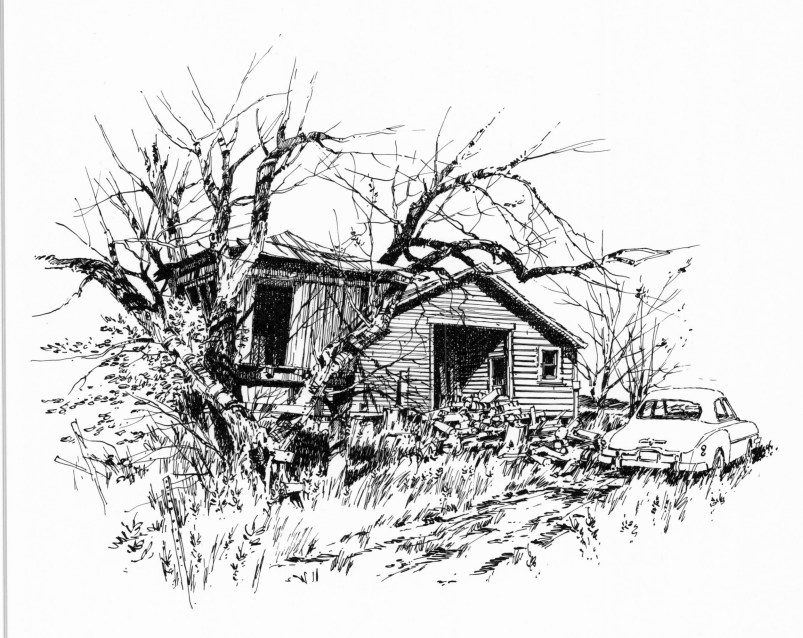

45. Jeff Kooser's treehouse, near Garland.

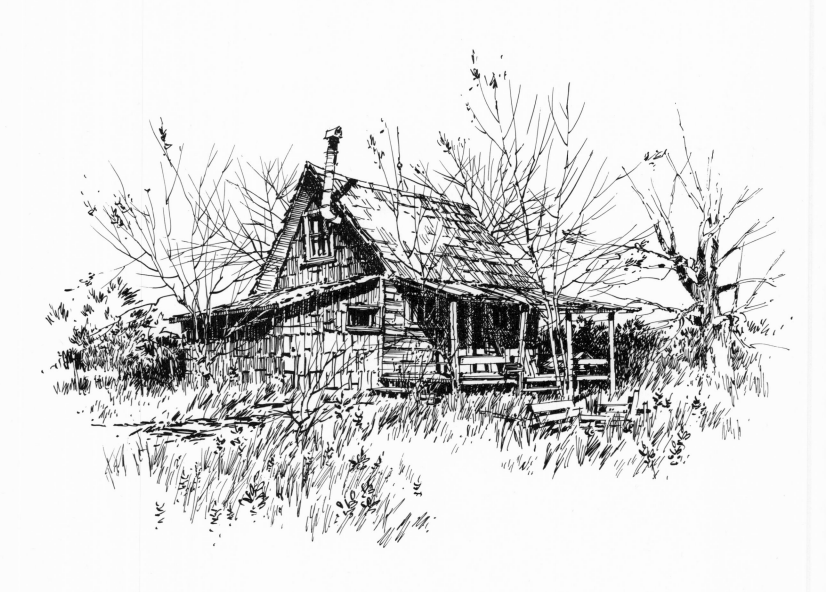

46. Roger Welsch's log cabin, built 1872 by Civil War veteran Tom Bishop near Pleasant Dale, relocated to near Dannebrog.

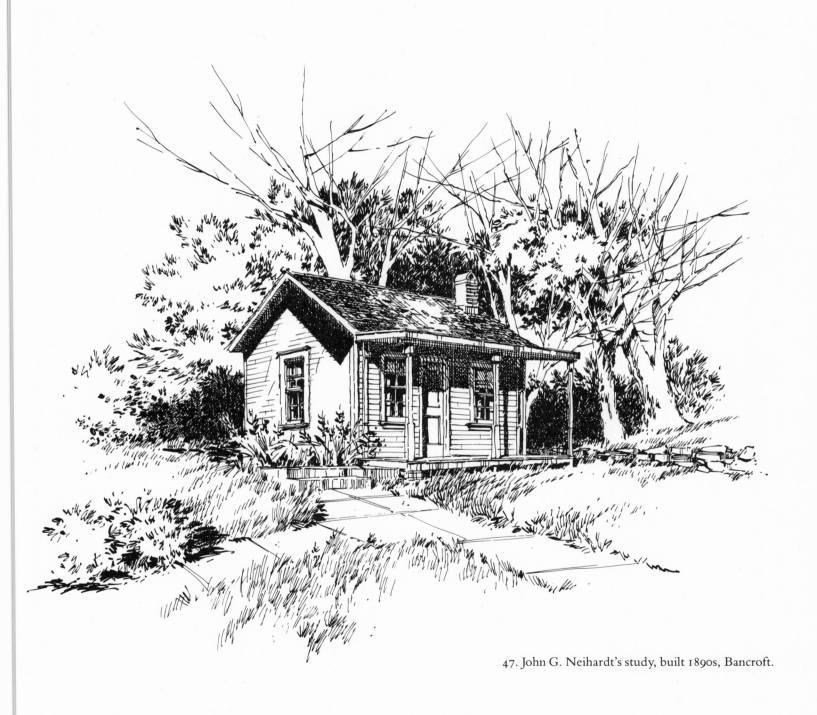

47. John G. Neihardt's study, built 1890s, Bancroft.

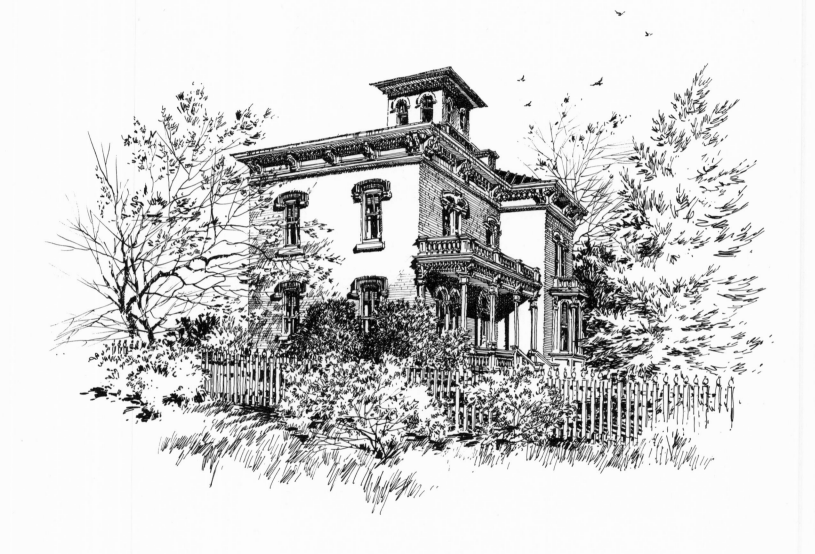

48. Thomas P. Kennard house, built 1869 for Nebraska's first secretary of state, Lincoln.

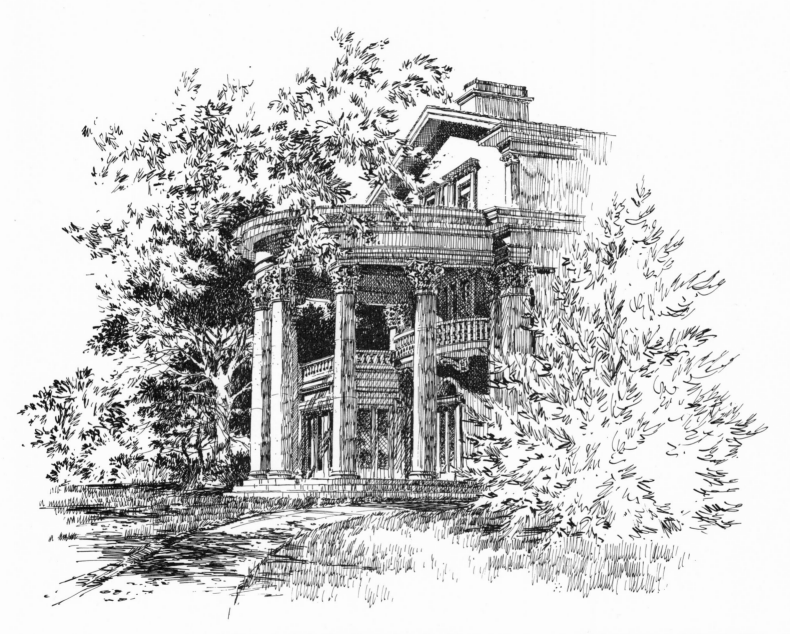

49. Arbor Lodge (J. Sterling Morton house), originally built 1855, remodeled several times, Nebraska City.

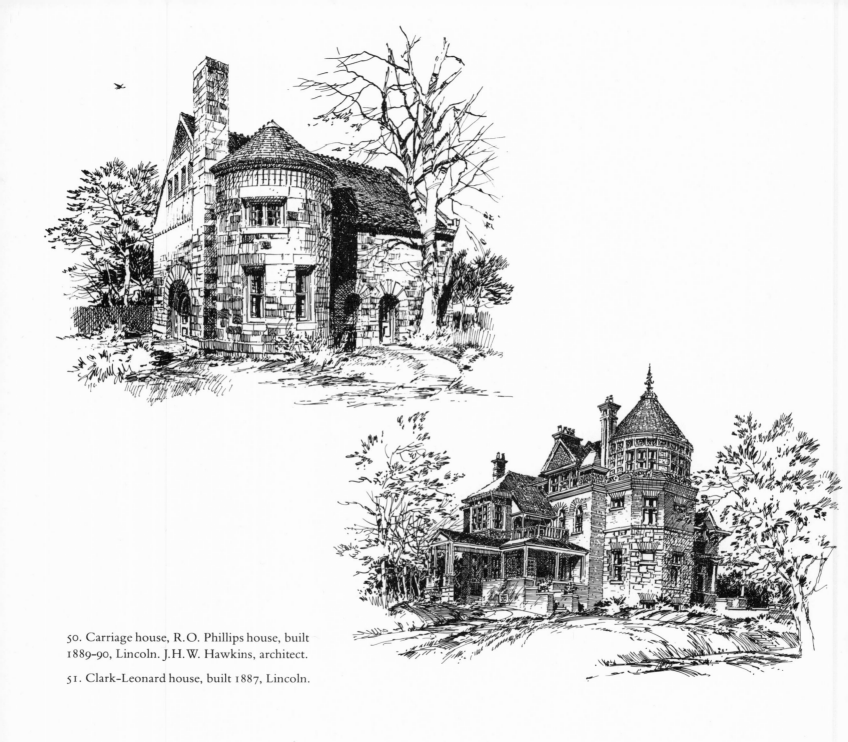

50. Carriage house, R.O. Phillips house, built 1889–90, Lincoln. J.H.W. Hawkins, architect.

51. Clark–Leonard house, built 1887, Lincoln.

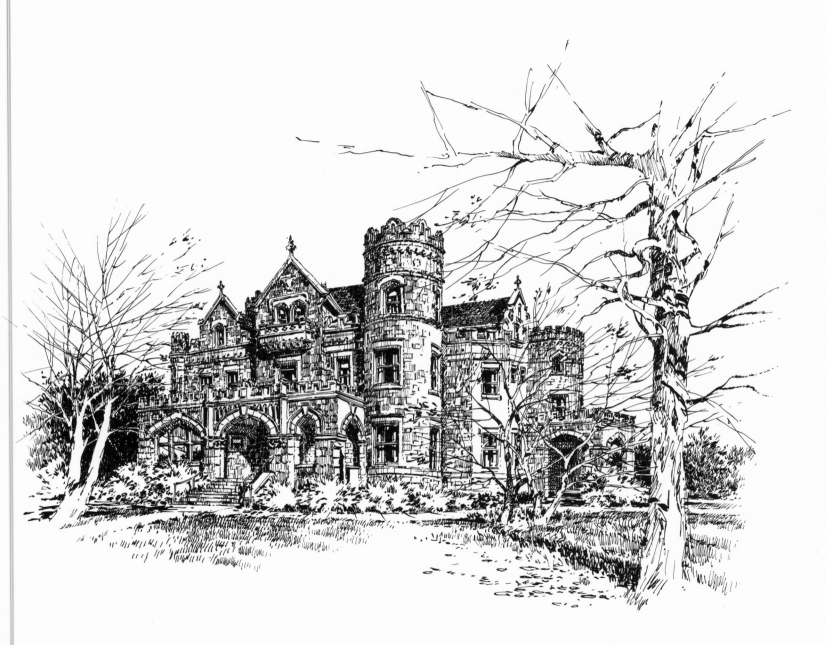

52. George A. Joslyn mansion, built 1902, Omaha. John McDonald, architect.

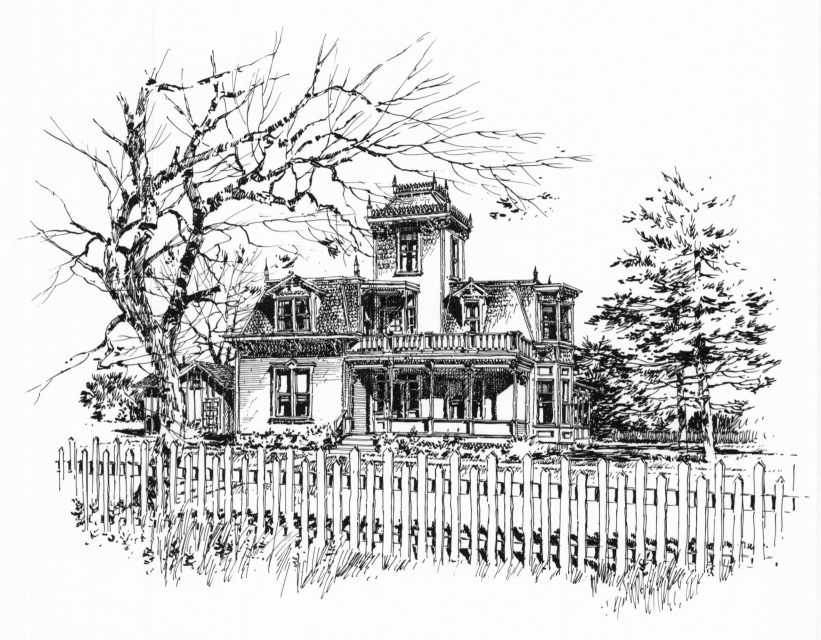

53. William F. "Buffalo Bill" Cody residence, built 1886, North Platte.

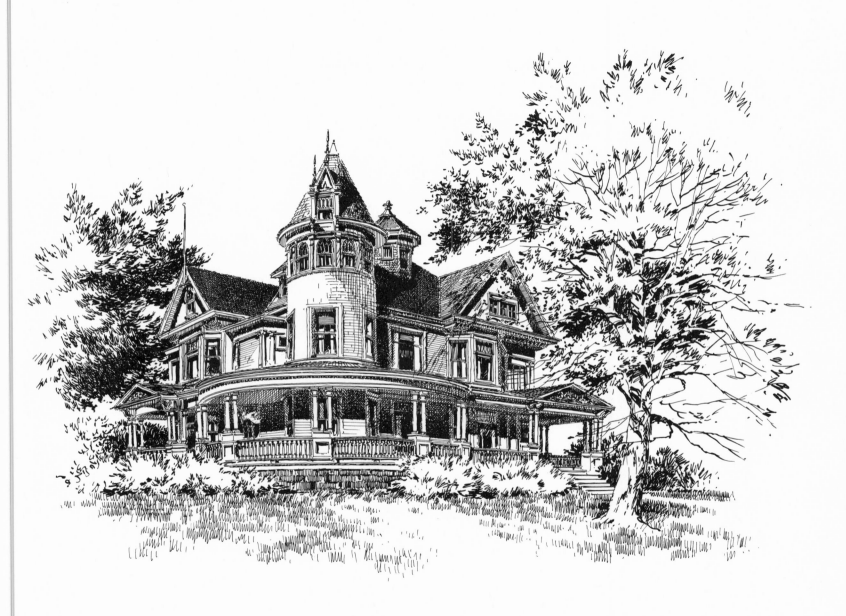

54. Andrew Hargis house (Grand Island Women's Club), built 1898, Grand Island.

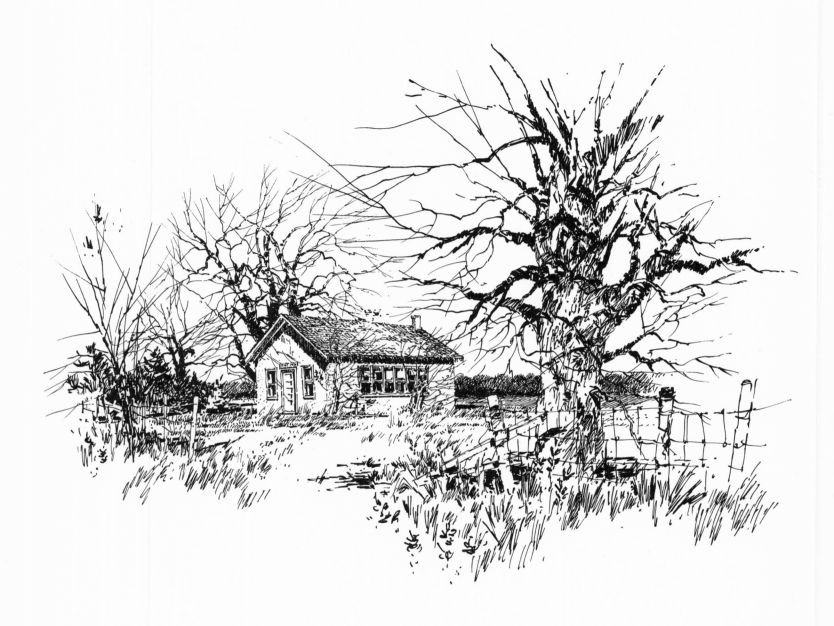

55. Country schoolhouse, District 196, south of Ewing.

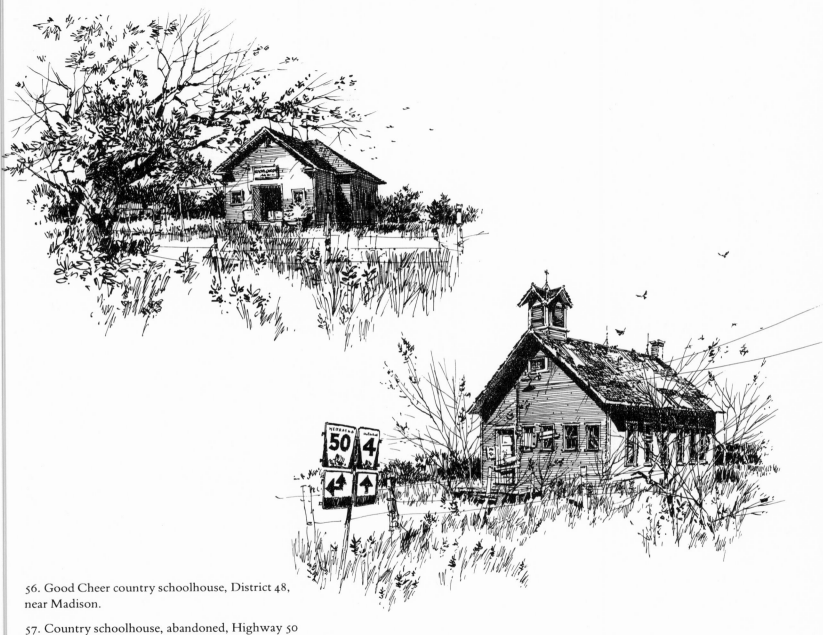

56. Good Cheer country schoolhouse, District 48, near Madison.

57. Country schoolhouse, abandoned, Highway 50 and Highway 4, Pawnee County.

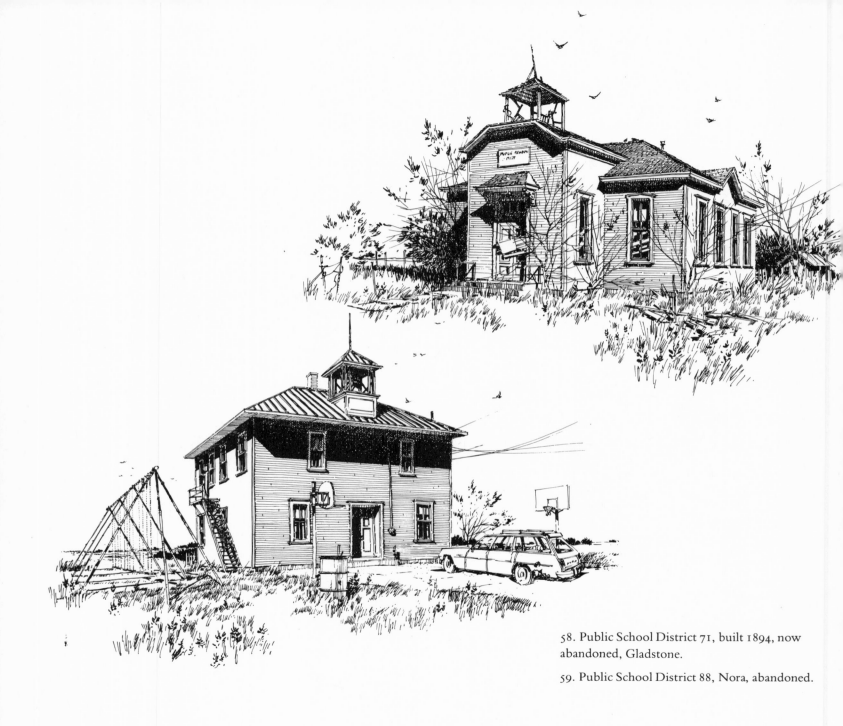

58. Public School District 71, built 1894, now abandoned, Gladstone.

59. Public School District 88, Nora, abandoned.

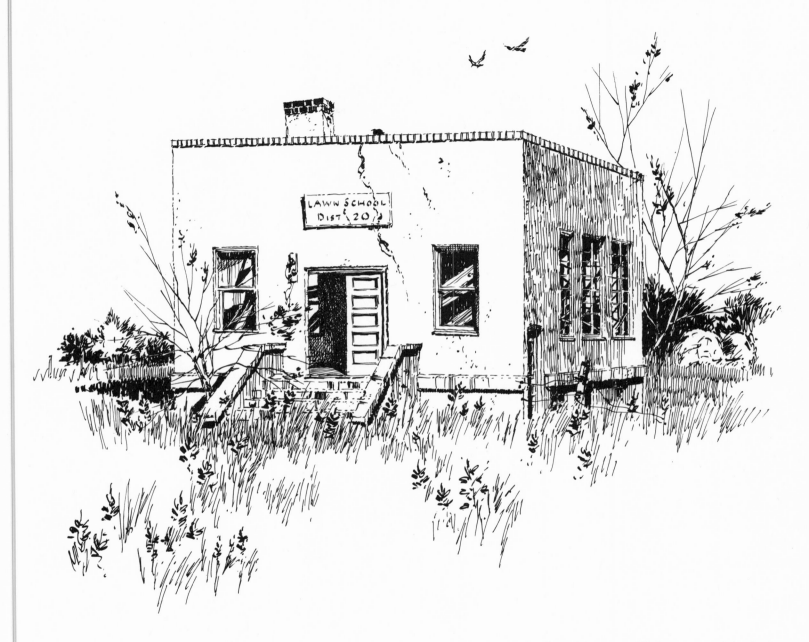

60. Lawn School, District 20, on Highway 2 near Marsland.

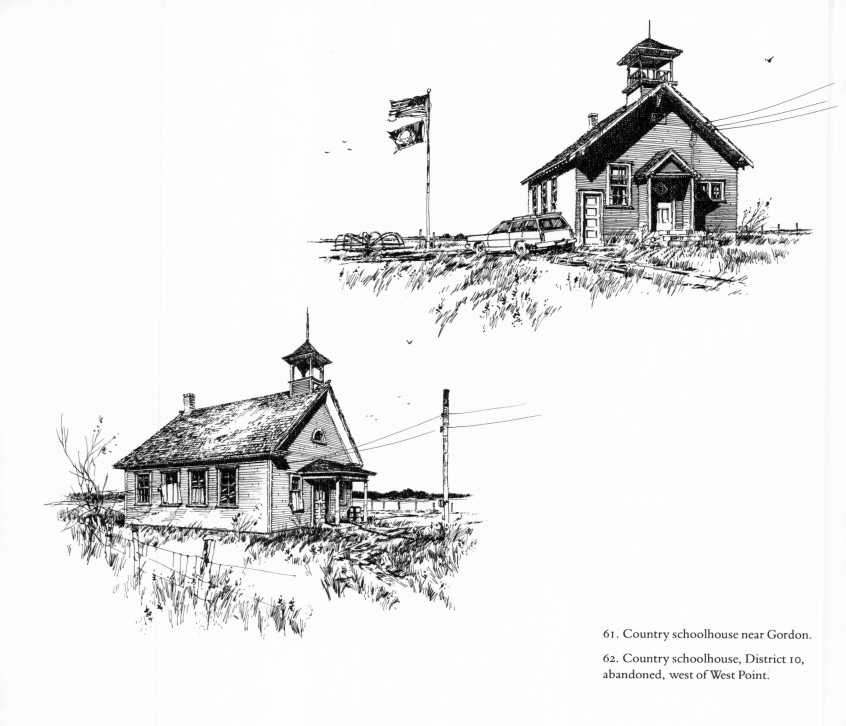

61. Country schoolhouse near Gordon.

62. Country schoolhouse, District 10, abandoned, west of West Point.

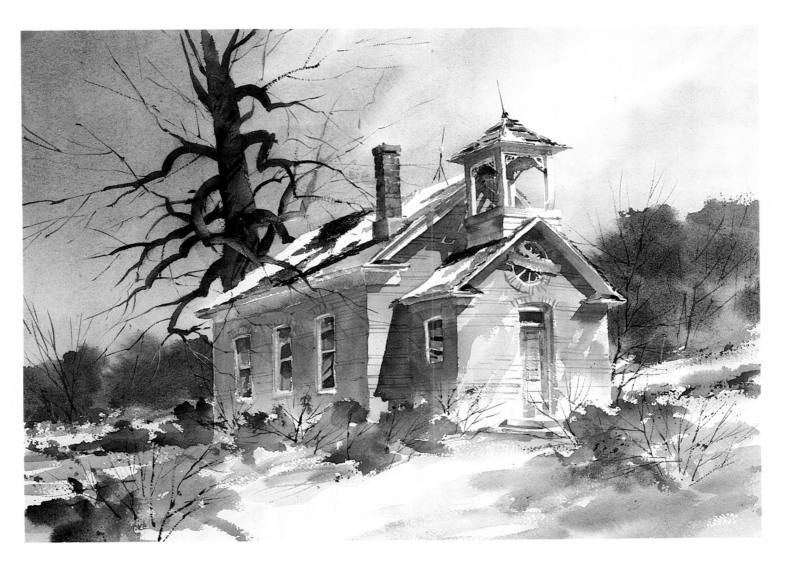

63. Country schoolhouse, abandoned, north of Auburn on Highway 75.

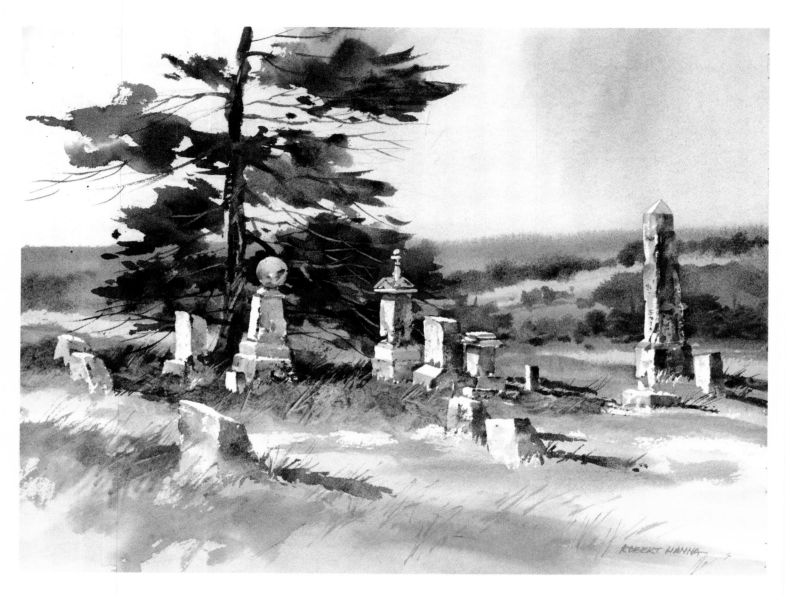

64. Walnut Grove Cemetery, established 1856, Brownville.

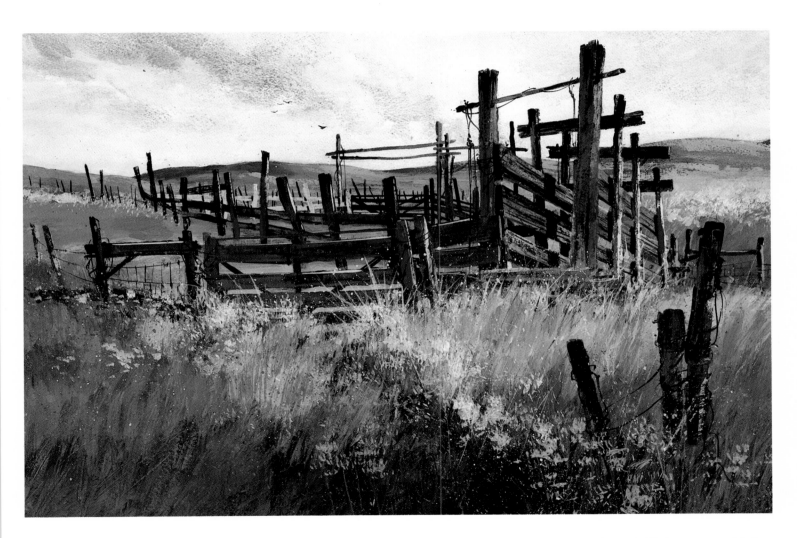

65. Cattle loading chute and corral, Highway 2 near Mullen.

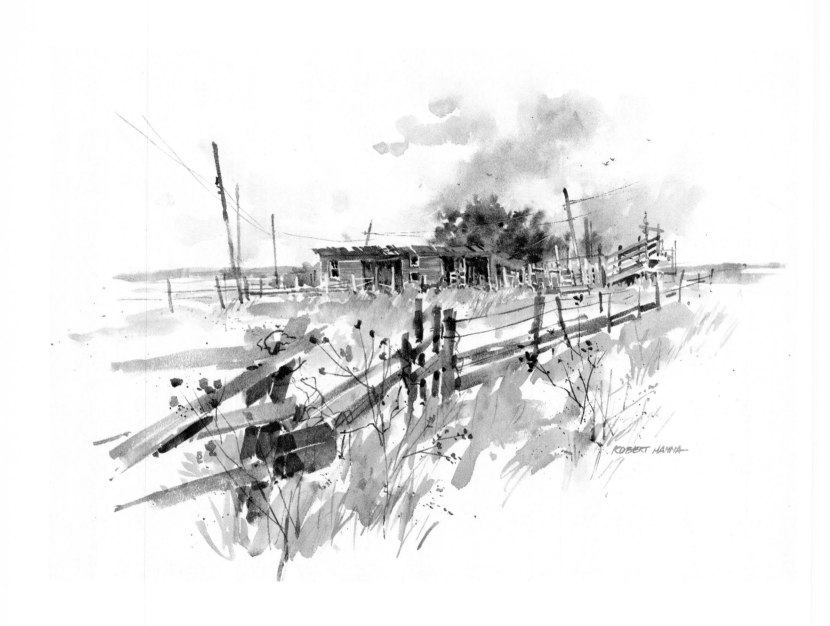

66. Corral and ranch shed, Sioux County.

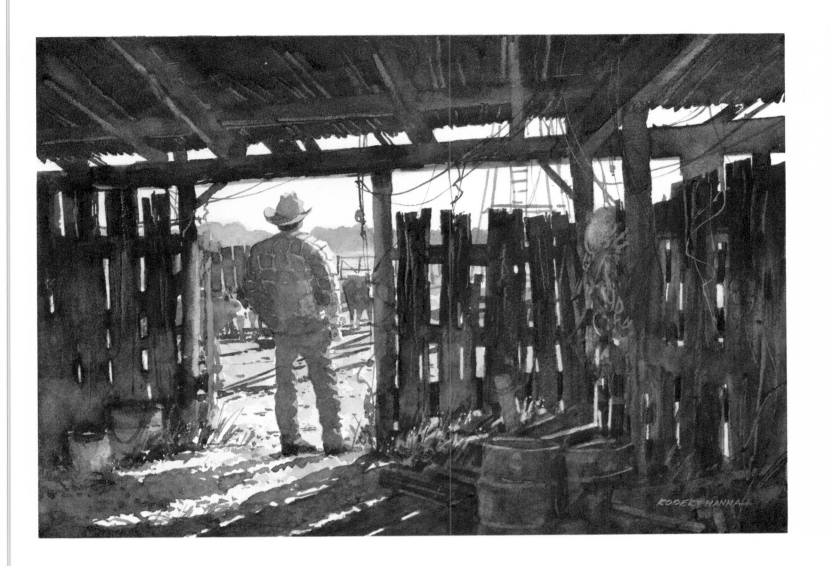

67. Rancher John Lee, Sandhills portrait, Brownlee.

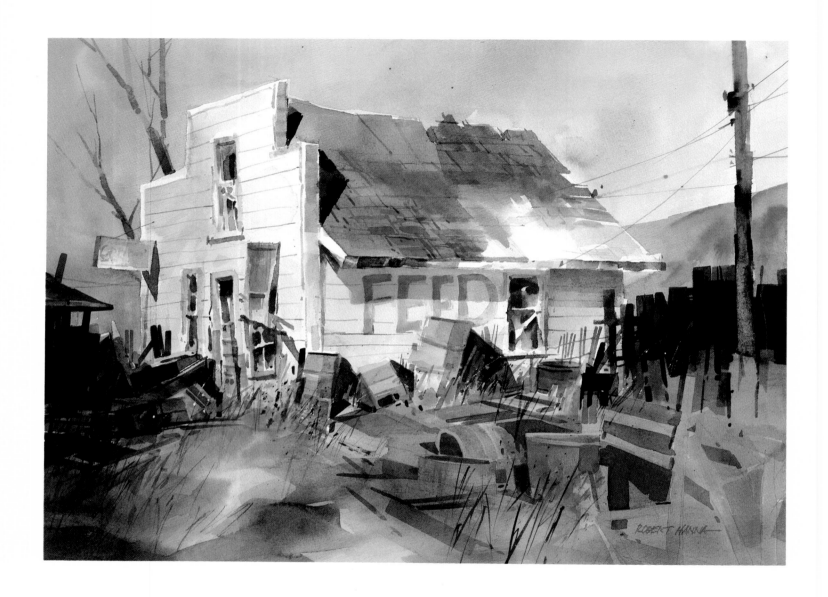

68. Feed store, Highway 6, Minden.

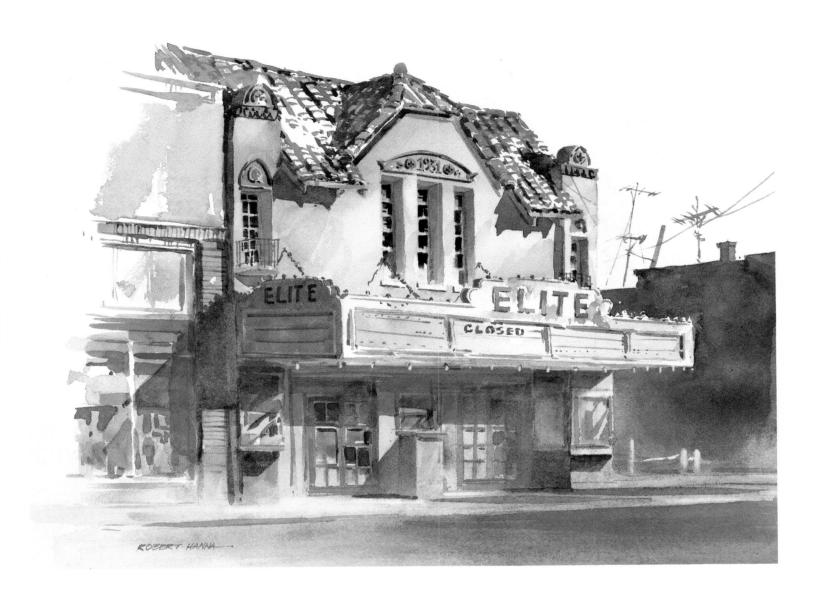

69. The Elite Theatre, Crawford.

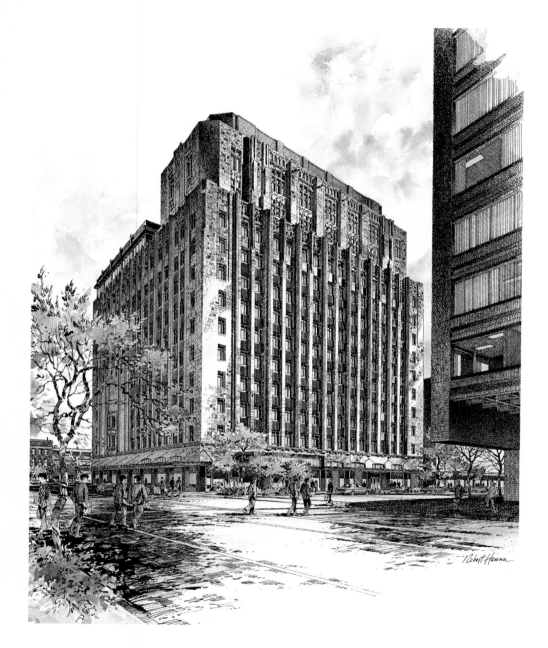

70. The Stuart Building (University Towers), built 1927, Lincoln, Ellery Davis, architect.

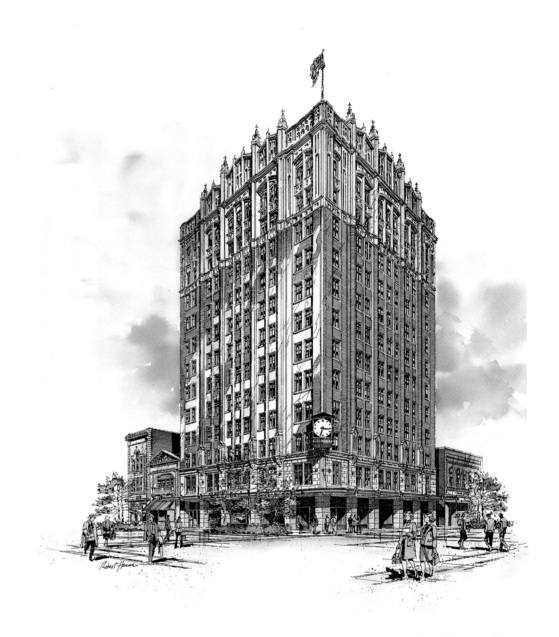

71. Lincoln Benefit Life Building, built 1927, Lincoln. Fiske and McGinnis architects.

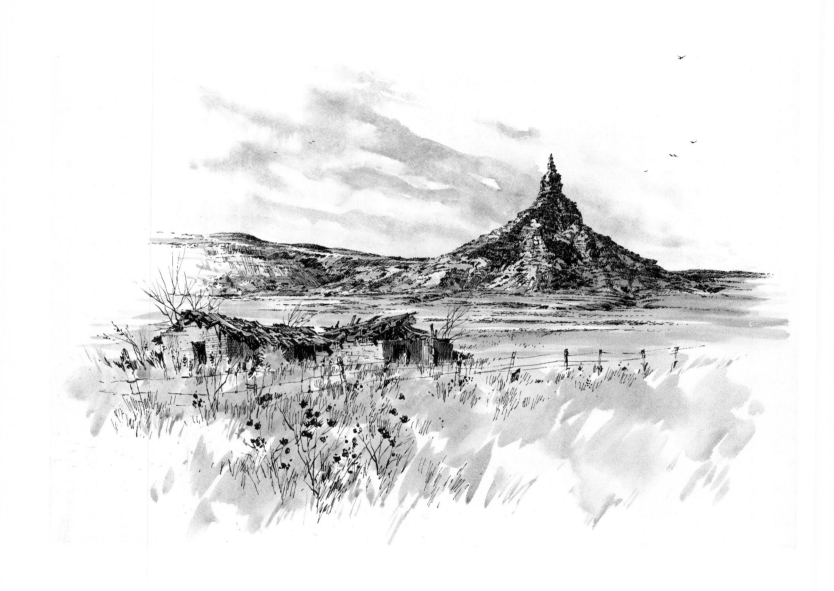

72. Chimney Rock and homestead ruins, Oregon–California Trail Landmark near Bayard.

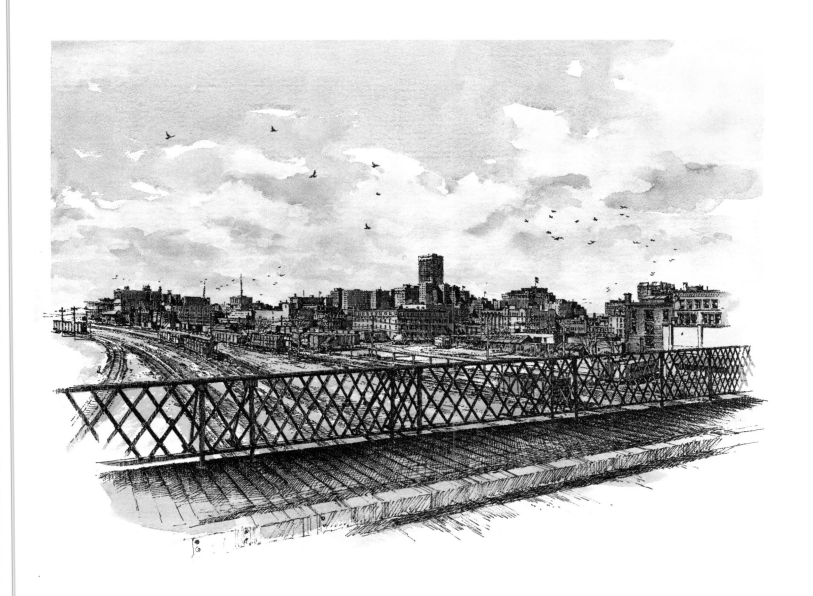

73. View of Omaha and the Old Market area from the Tenth Street Bridge, Omaha.

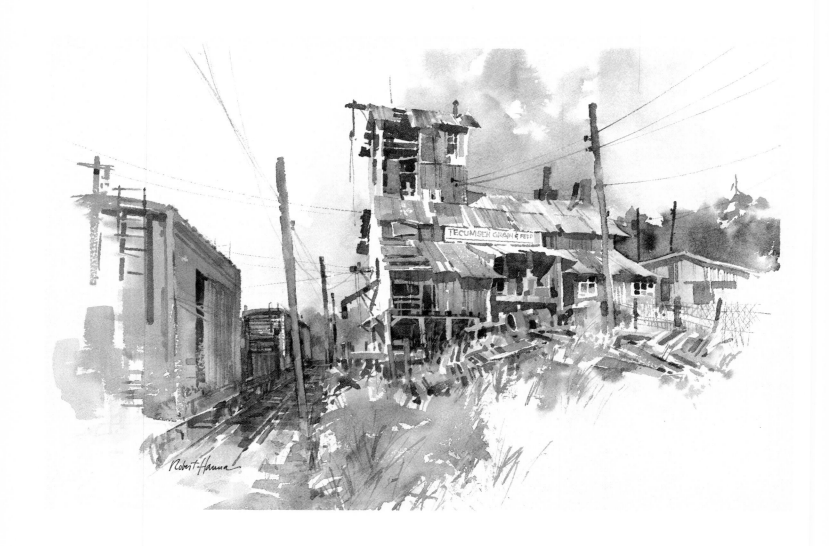

74. Abandoned Grain Elevator, Tecumseh.

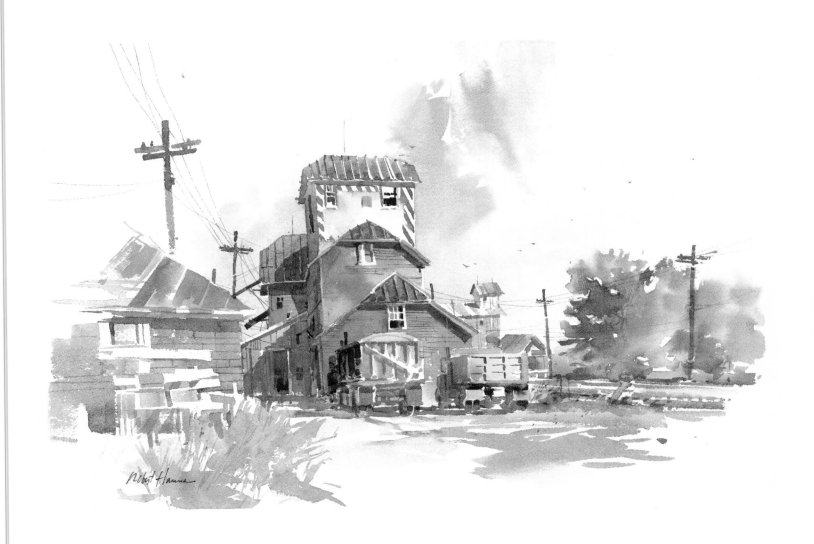

75. Neligh Grain Elevator, Neligh.

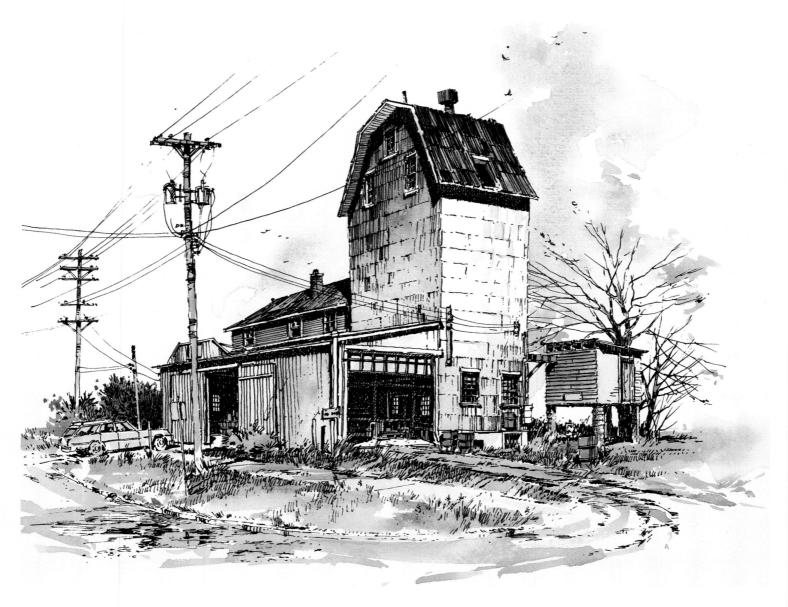

76. The Mormon Mill, built 1846-47, Florence.

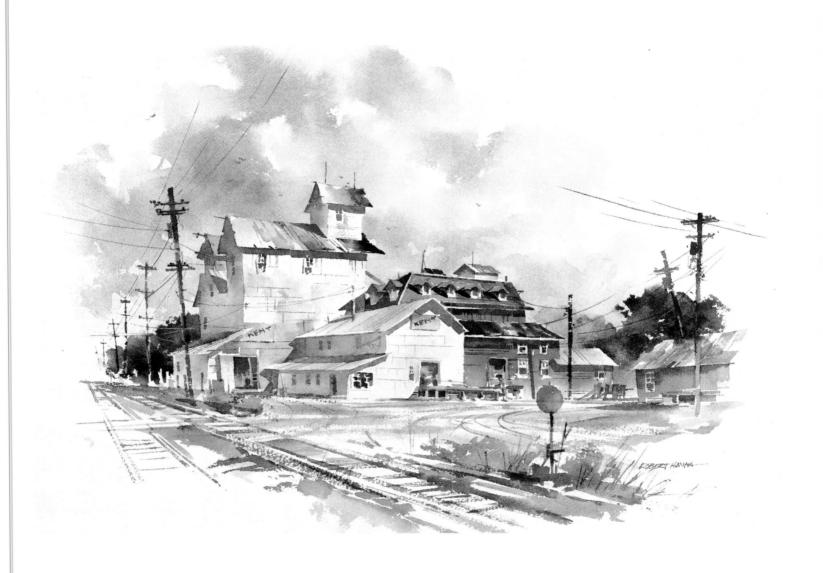

77. Neligh Mill, construction started 1873, and grain elevator, Neligh.

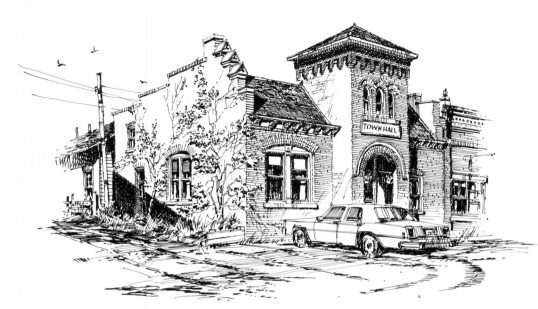

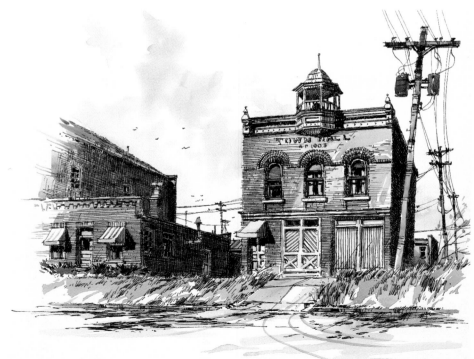

78. Town Hall, built 1896, Dodge.

79. Town Hall, built 1903, Snyder.

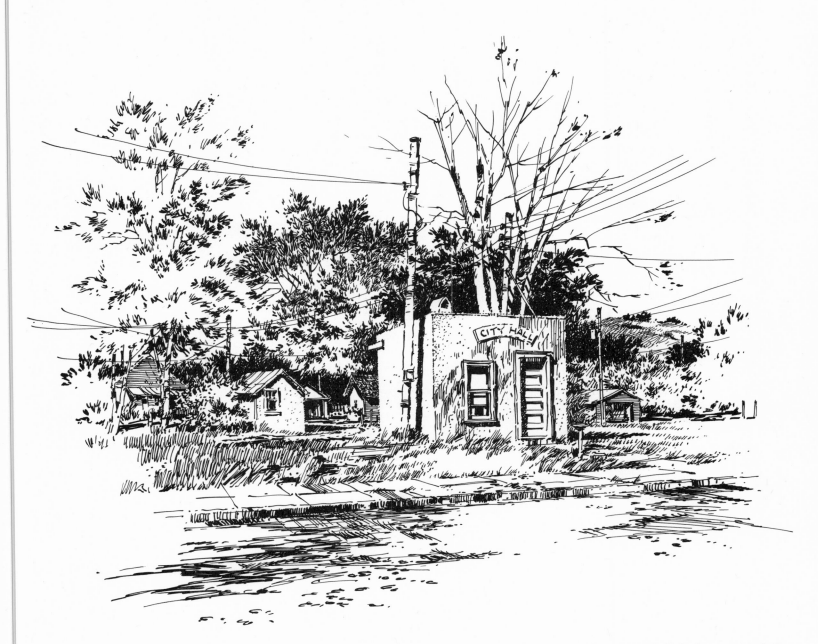

80. City hall, built 1936, Maskell.

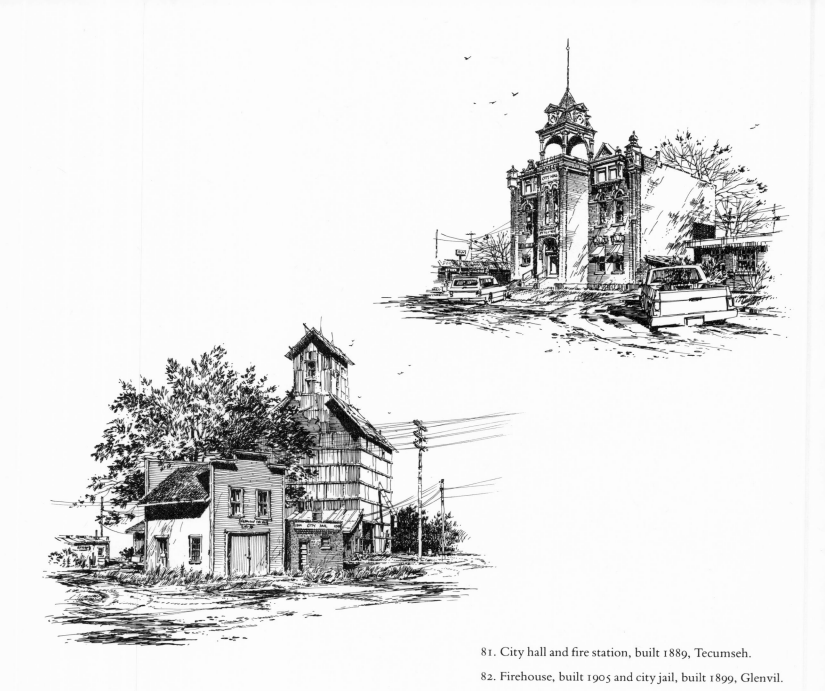

81. City hall and fire station, built 1889, Tecumseh.

82. Firehouse, built 1905 and city jail, built 1899, Glenvil.

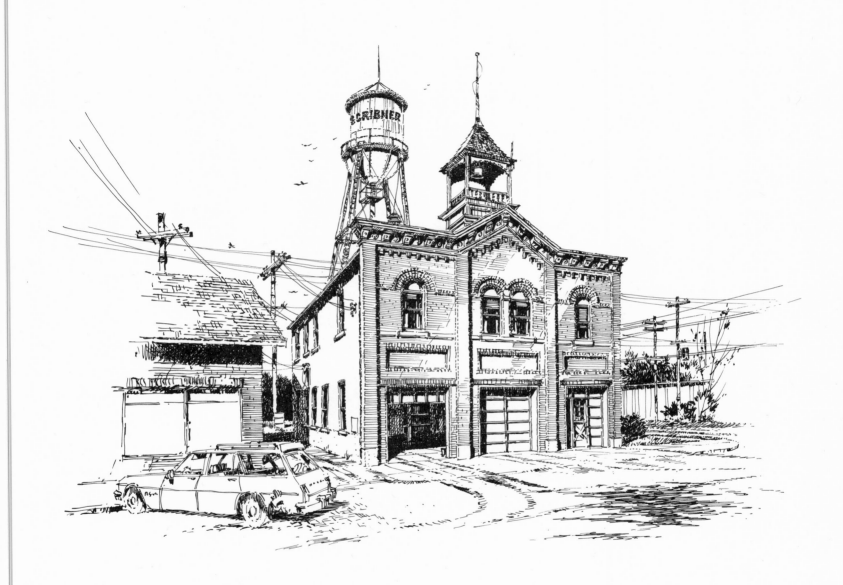

83. City hall, fire station, and water tower, built 1906, Scribner.

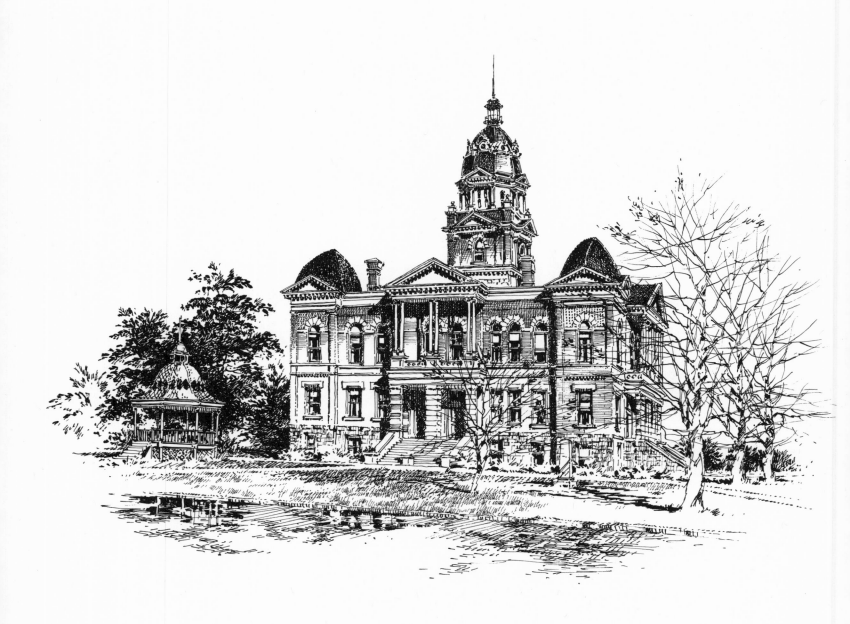

84. Johnson County courthouse, built 1899, Tecumseh. William Gray, architect.

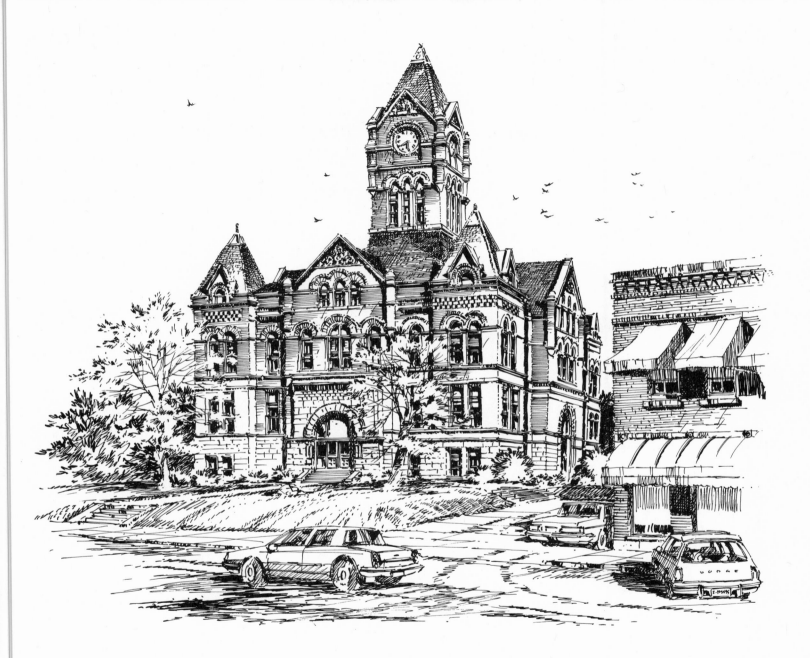

85. Cass County courthouse, built 1892, Plattsmouth. William Gray, architect.

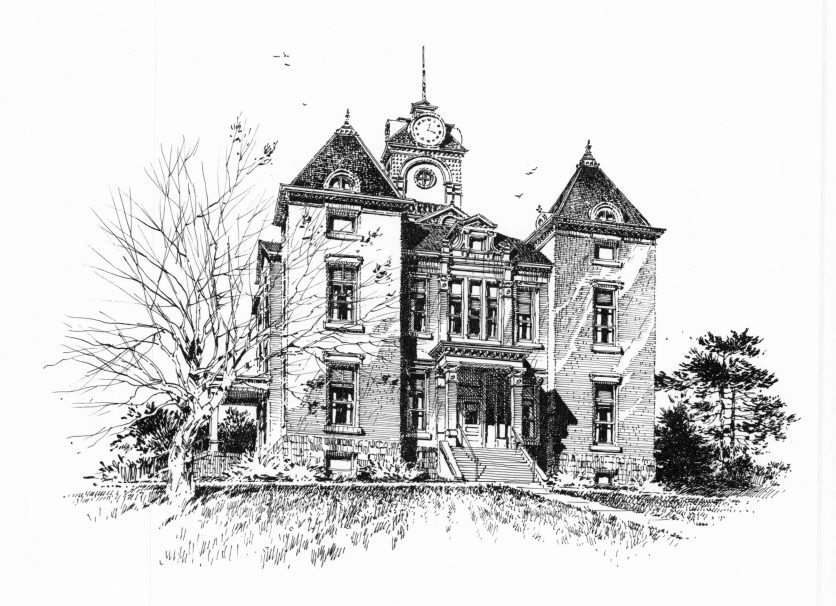

86. Nuckolls County courthouse, built 1899, Nelson. George McDonald, architect.

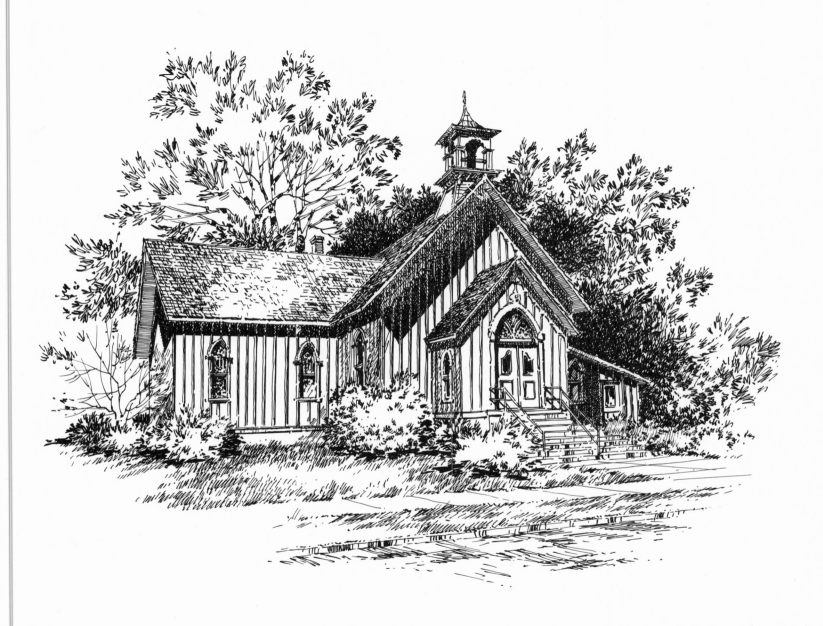

87. Congregational Church, constructed 1874, Blair. Charles Driscoll, architect.

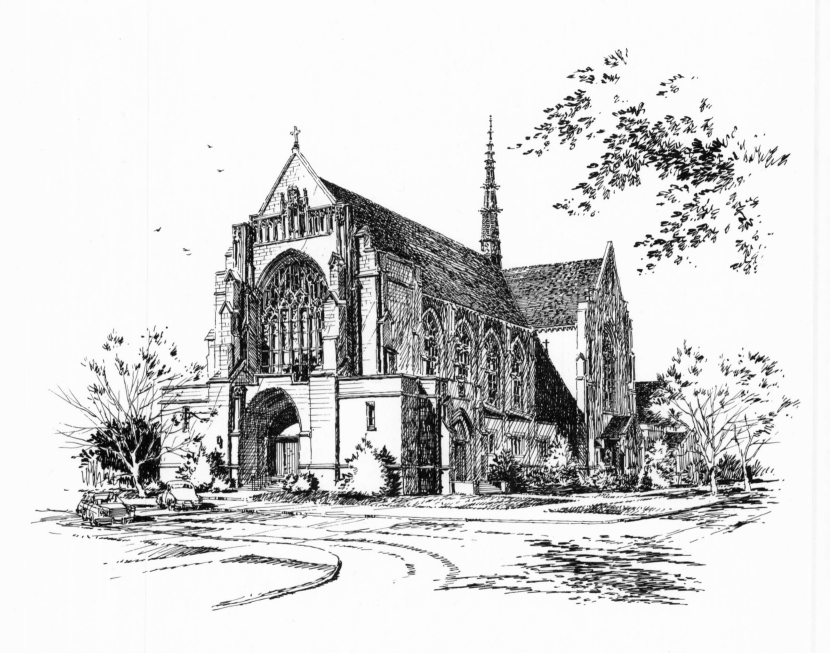

88. Cathedral of the Nativity of the Blessed Virgin Mary, constructed 1926–28, Grand Island. Brinkman and Hagen, architects.

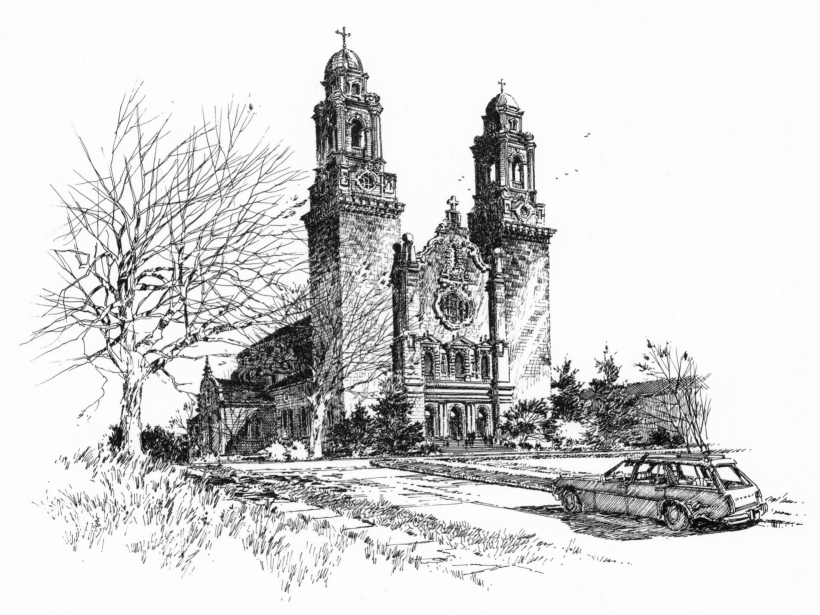

89. St. Cecilia's Cathedral, construction started 1907, Omaha. Thomas Rogers Kimball, architect.

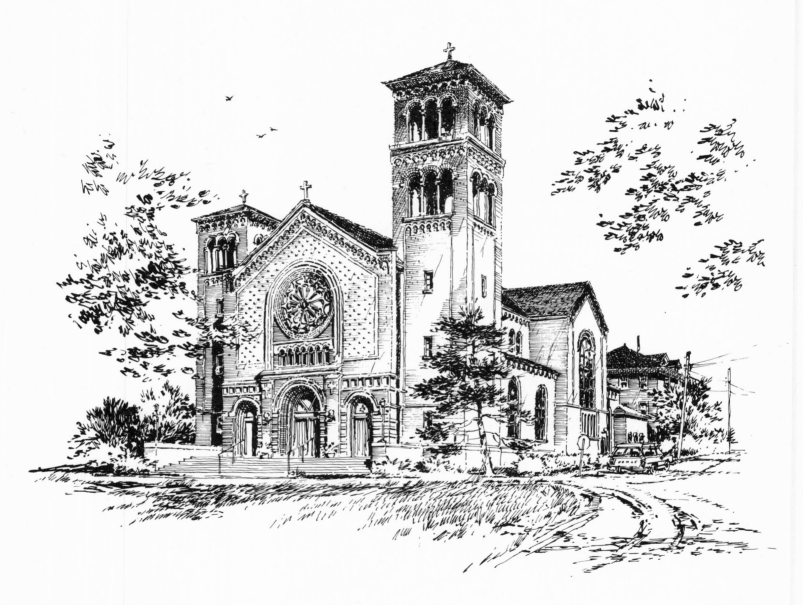

90. St. Anthony's Church, built 1926, Steinhauer.

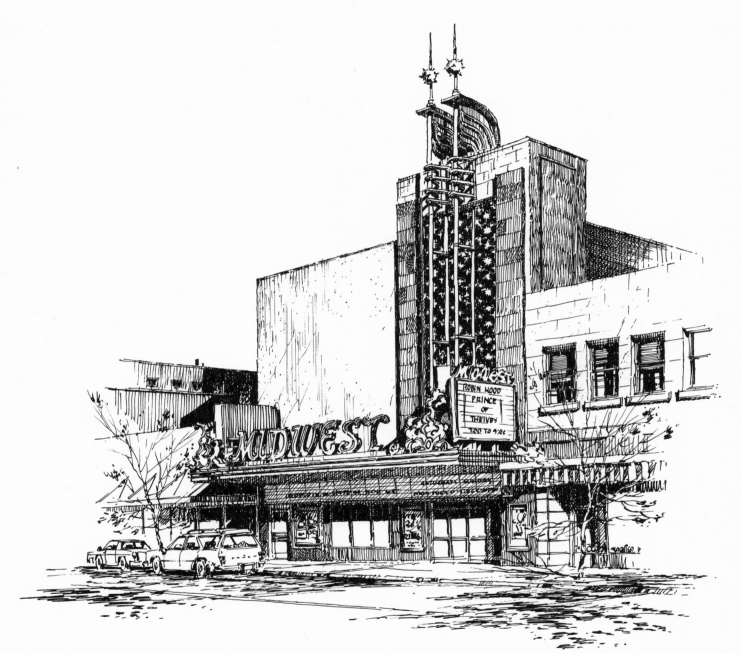

91. The Midwest Theatre, Scottsbluff.

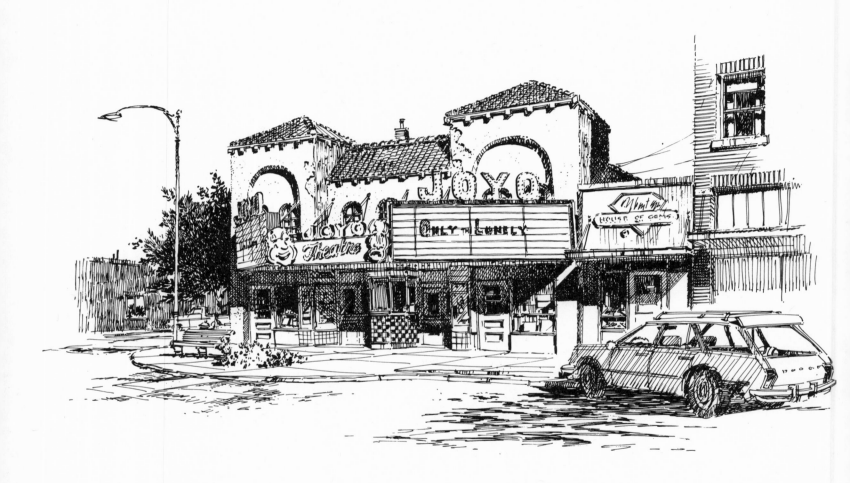

92. The Joyo Theatre, built 1936, Havelock (Lincoln).

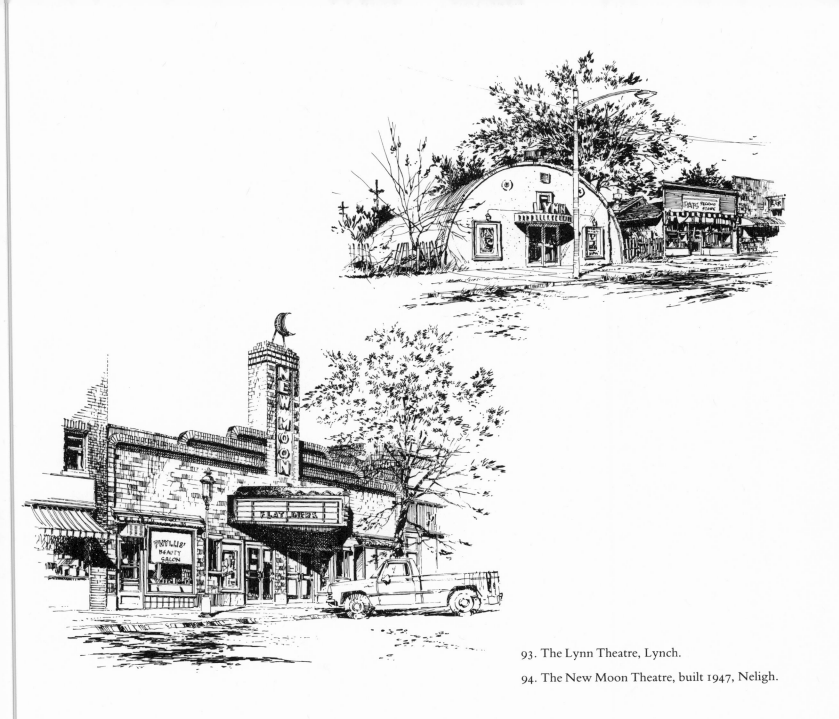

93. The Lynn Theatre, Lynch.

94. The New Moon Theatre, built 1947, Neligh.

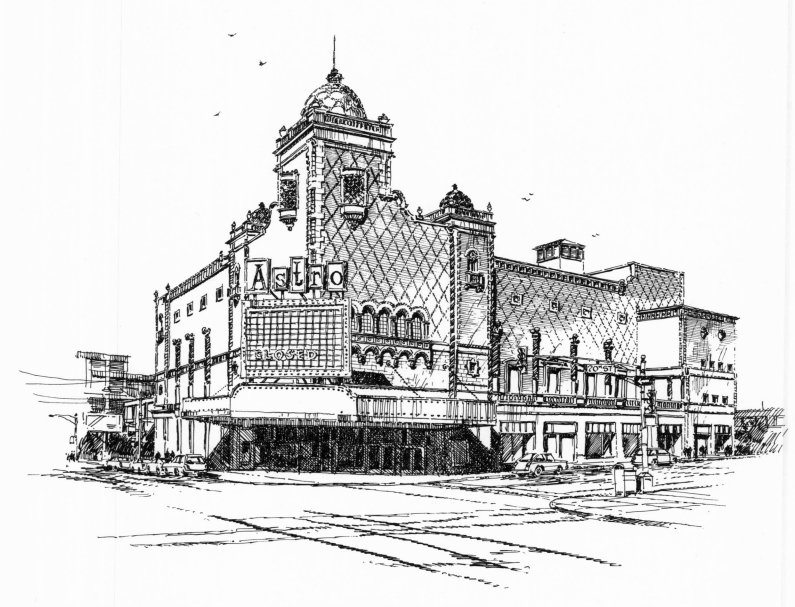

95. The Astro Theatre, opened as the Riviera in 1926, Omaha. John Eberson, architect.

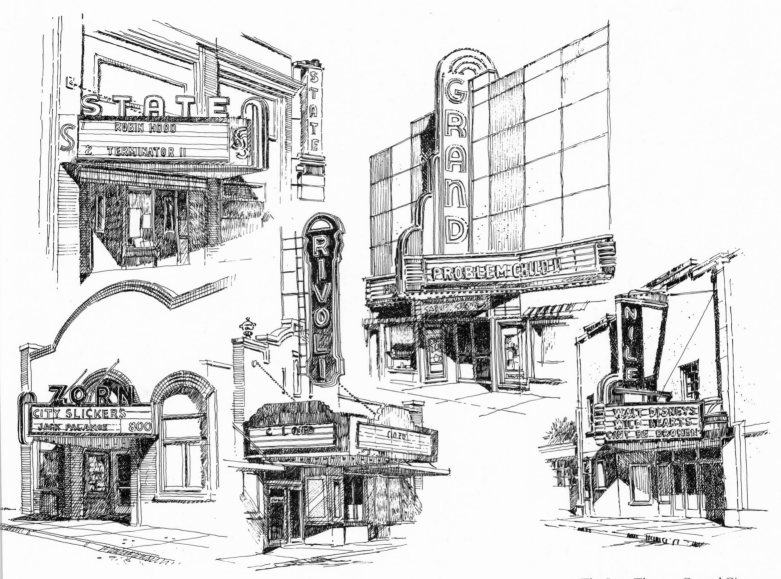

96. The State Theatre, Central City.
97. The Zorn Theatre, Benkelman.
98. The Rivoli Theatre, Falls City.
99. The Grand Theatre, Grand Island.
100. The Nile Theatre, Mitchell.

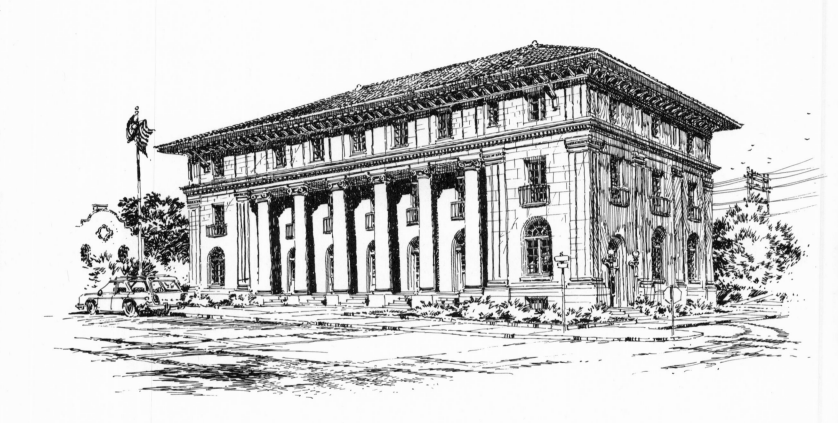

101. U.S. post office and courthouse, built 1914-16, McCook. O.E. Wenderoth, architect.

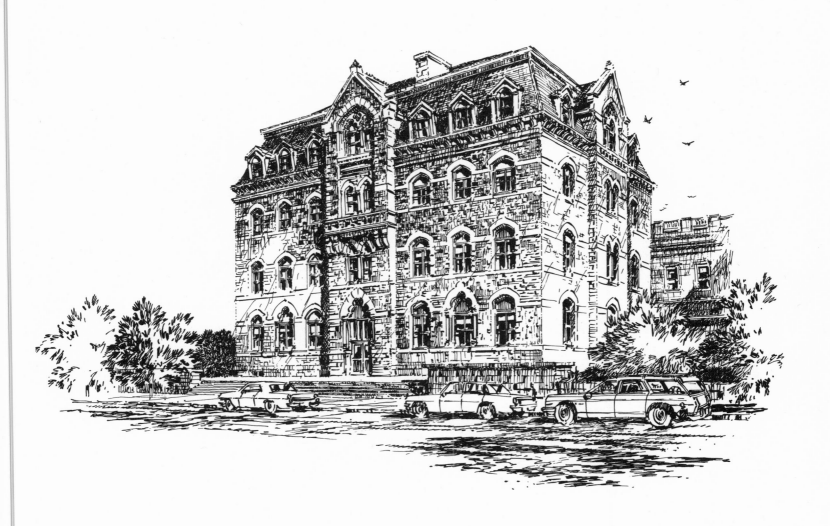

102. U.S. post office and courthouse (old City Hall), constructed 1874-79, Lincoln. Alfred B. Mullet and William Porter, architects.

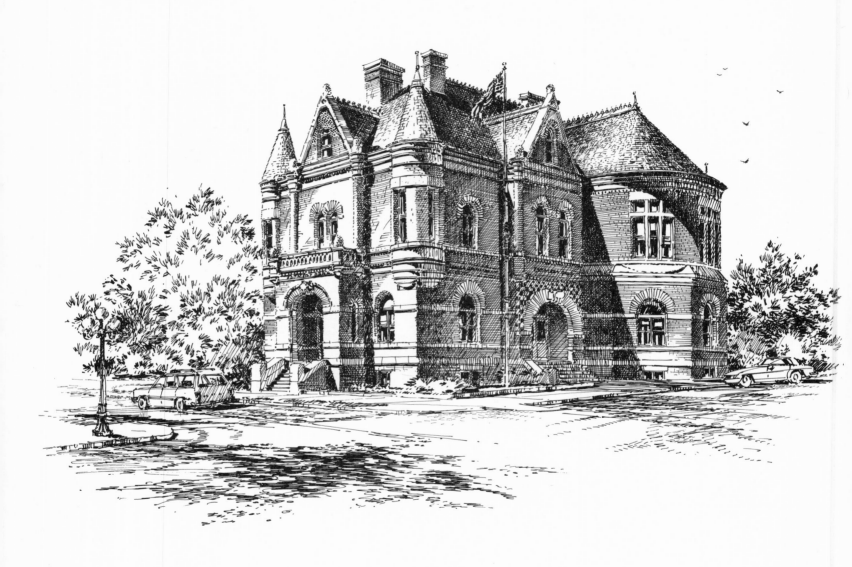

103. U.S. post office and courthouse (Farmers Bank), completed 1889, Nebraska City. W.E. Bell, architect.

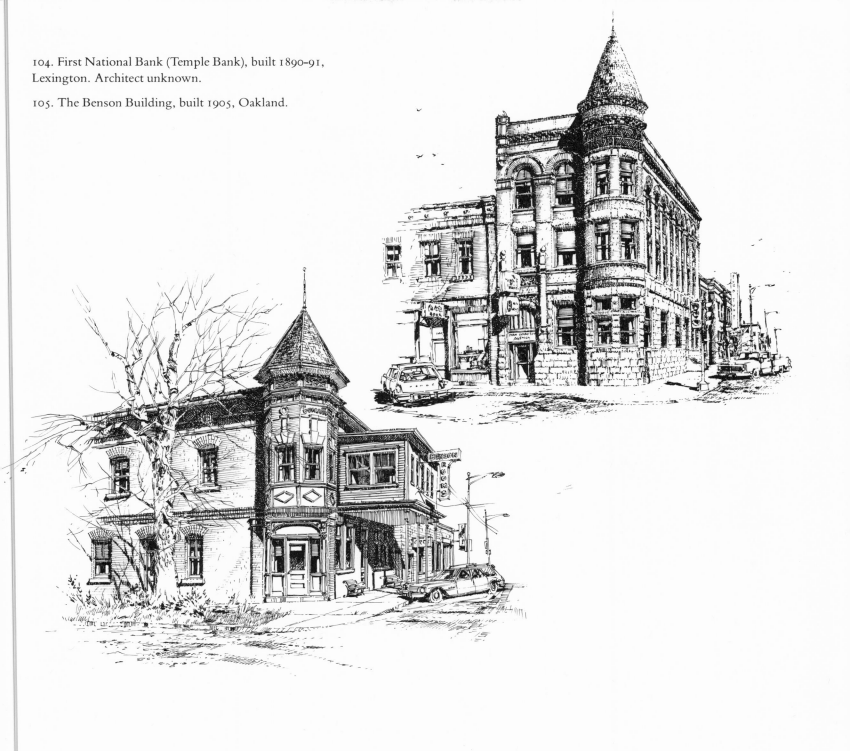

104. First National Bank (Temple Bank), built 1890–91, Lexington. Architect unknown.

105. The Benson Building, built 1905, Oakland.

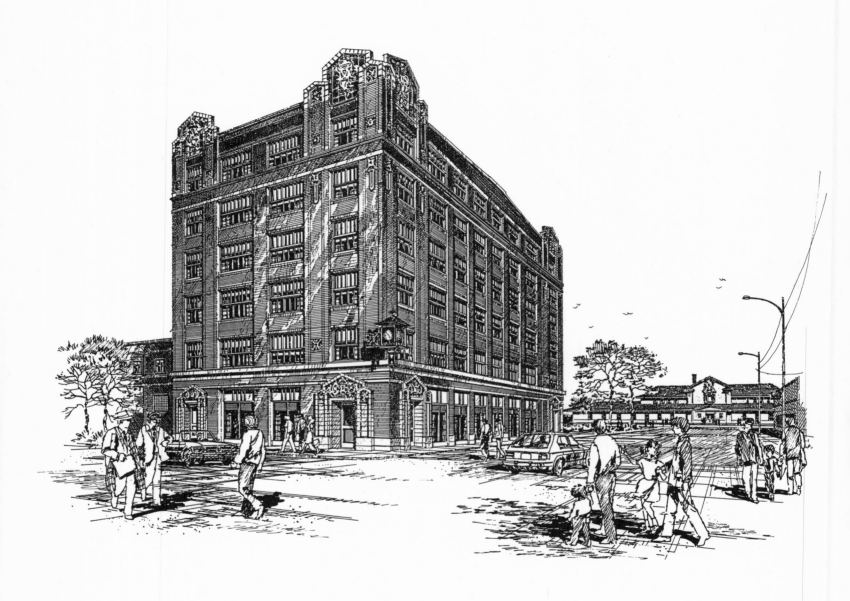

106. The Victory Building (Dutton–Lainson Building) completed 1920, Second street, Hastings.

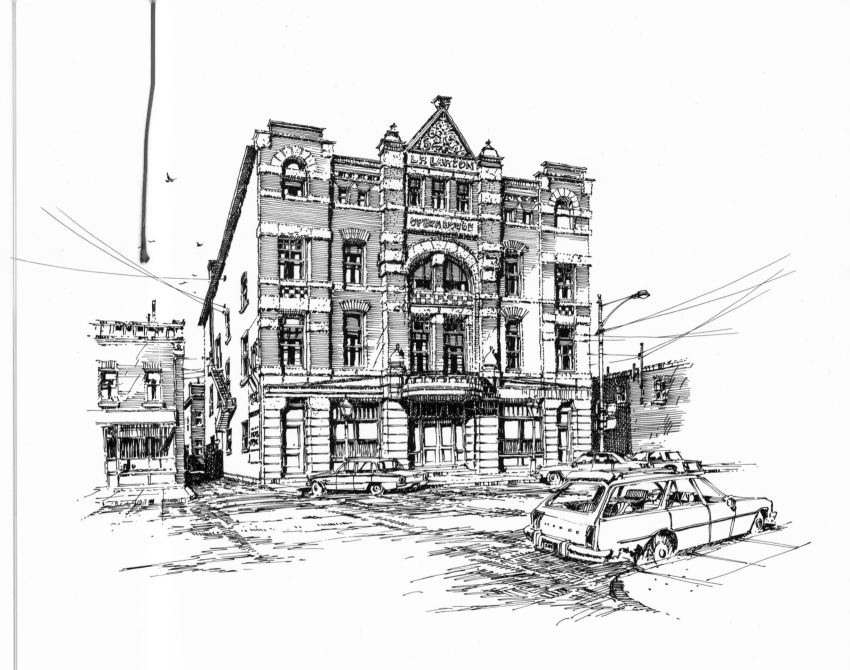

107. Love-Larson Opera House, built 1888, Fremont. F.M. Ellis, architect.

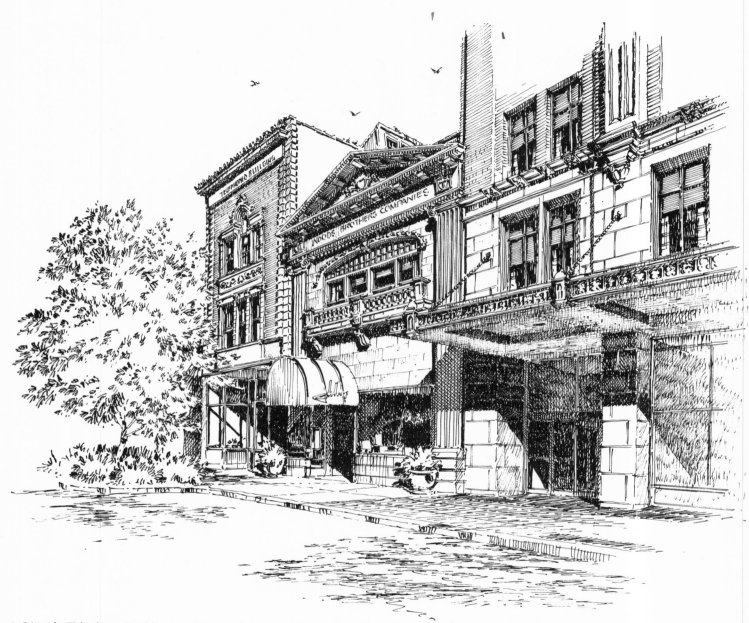

108. Lincoln Telephone Building, constructed 1894–95 (Thomas Rogers Kimball, architect) and Woods Brothers Investment Building, completed 1916, Lincoln.

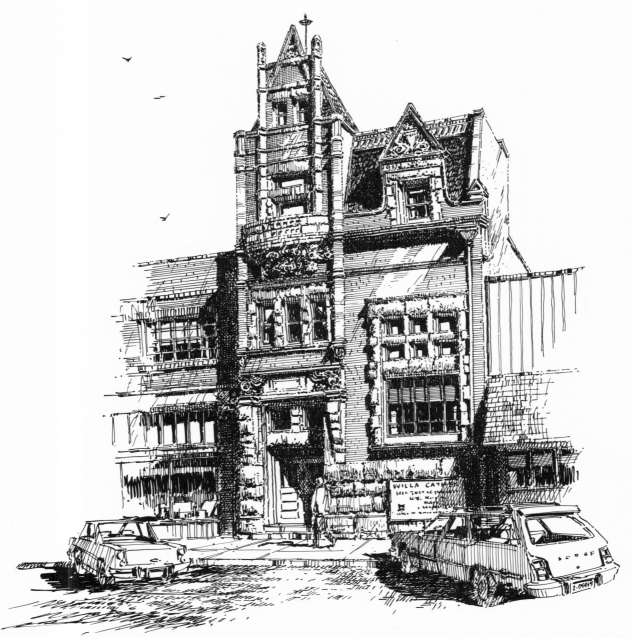

109. Silas Garber bank (Willa Cather Museum) built 1888–89, Red Cloud.

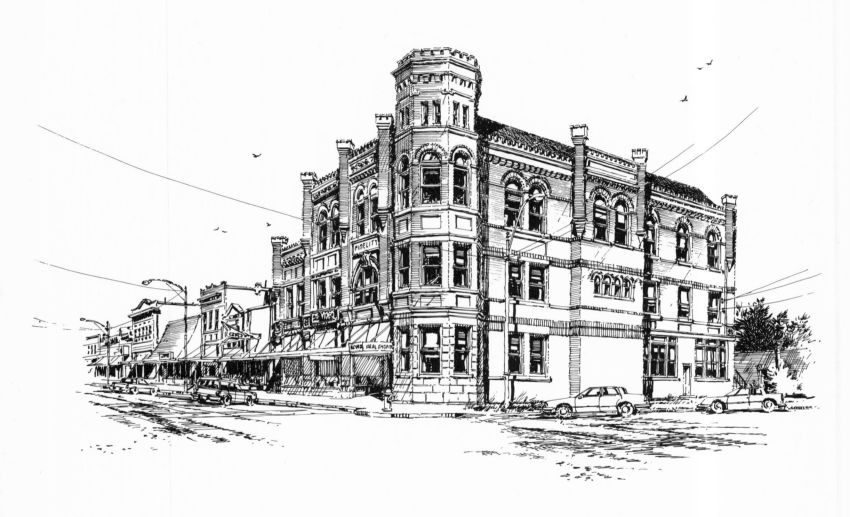

110. The Royal Highlanders Building, built 1896, Aurora. Design inspired by Balmoral Castle in Scotland.

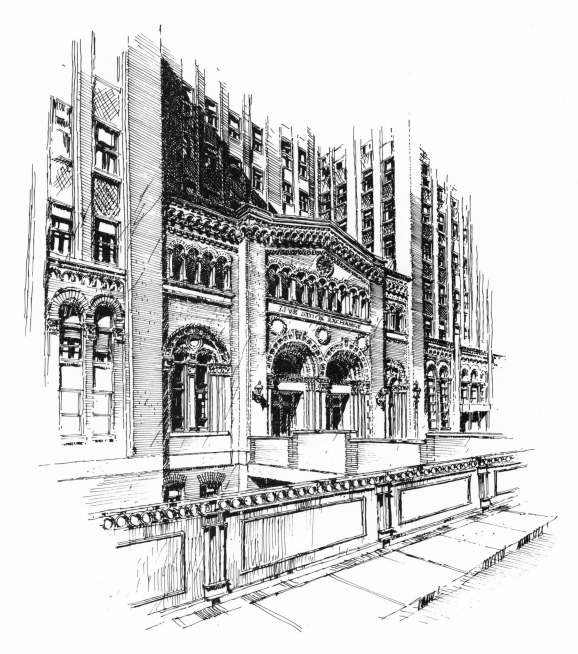

111. The Livestock Exchange Building, erected 1926, Omaha. George B. Prinz, architect.

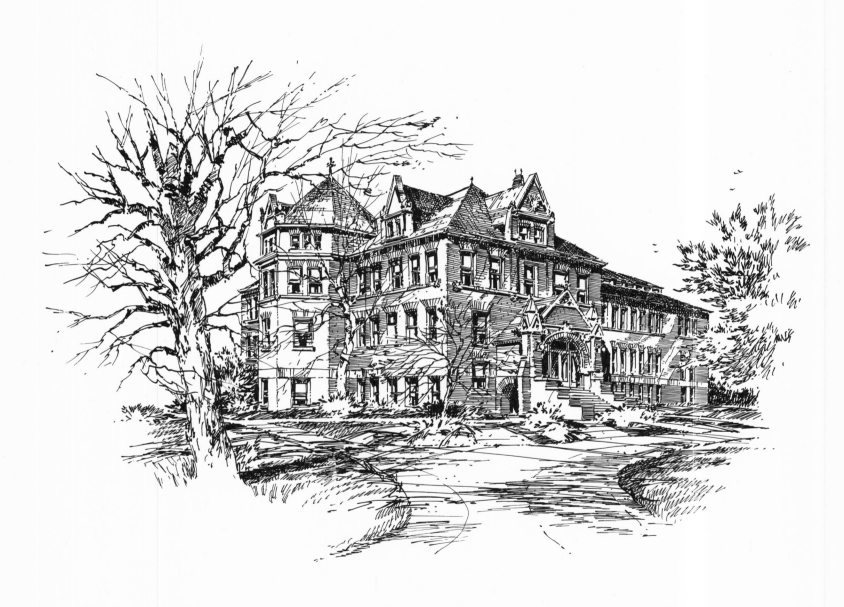

112. Old University Library (Architecture Hall), constructed 1891-95, Lincoln. Mendelssohn, Fisher and Lawrie, architects.

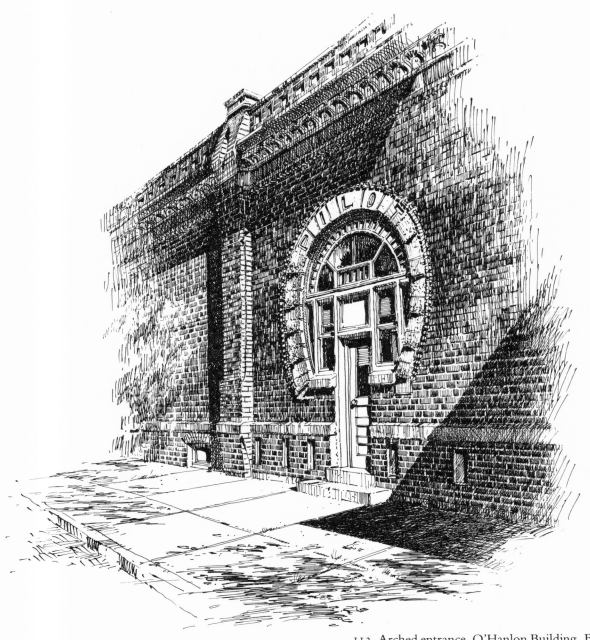

113. Arched entrance, O'Hanlon Building, Blair, built 1890.

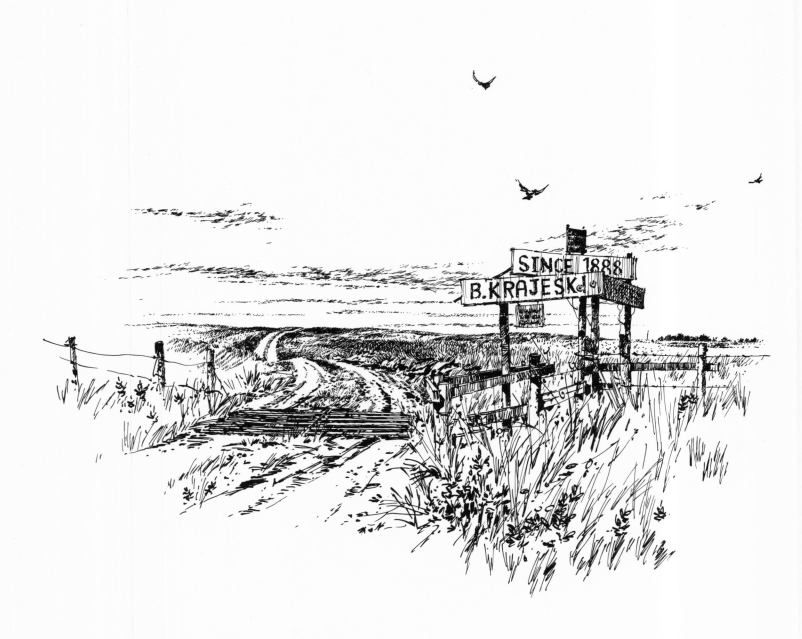

114. Ranch entry on Highway 20 west of Kilgore.

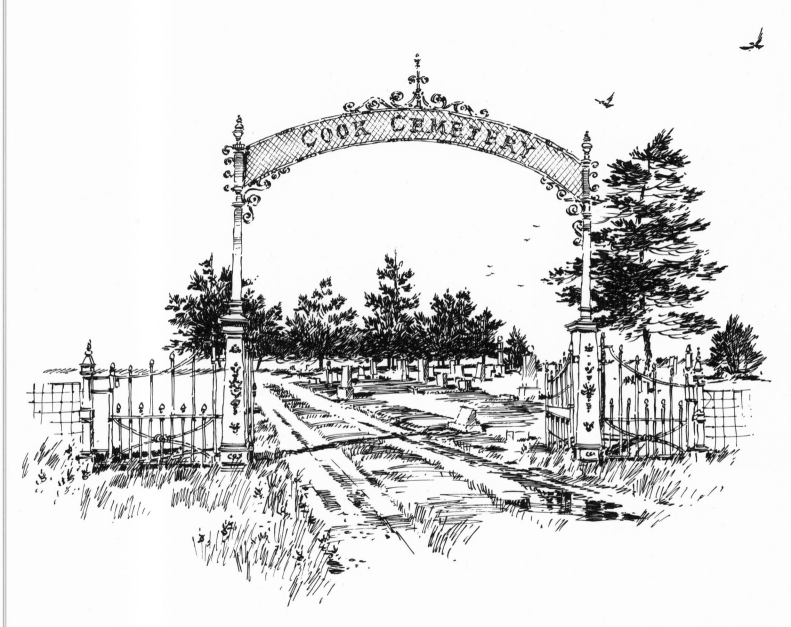

115. Cemetery entry gate near Cook.

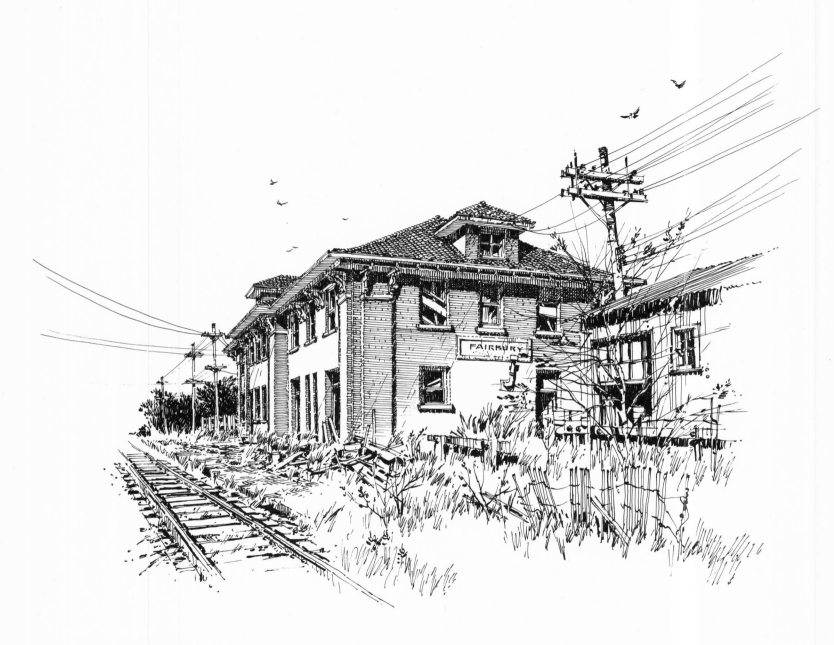

116. Rock Island Railroad depot, built 1914, abandoned, Fairbury.

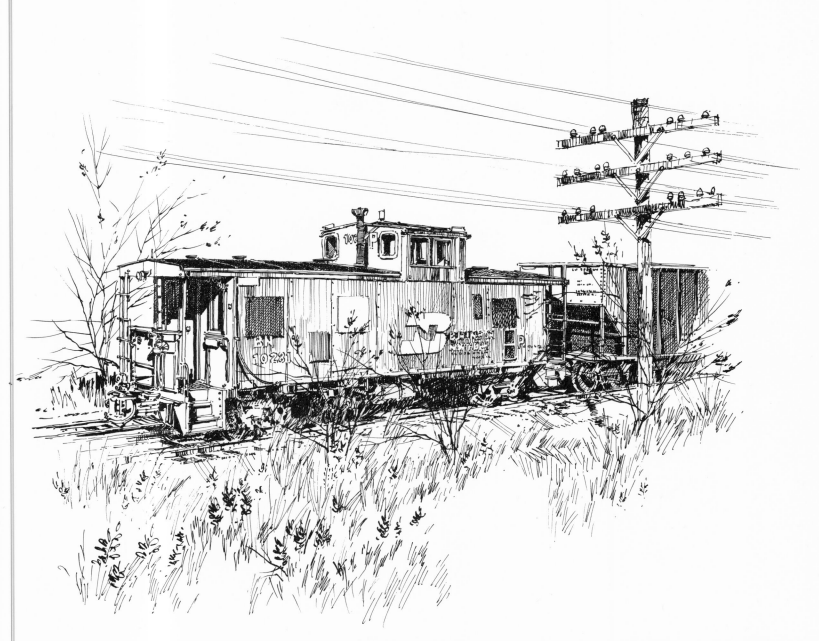

117. Burlington caboose (no longer required on Nebraska trains), near Greenwood.

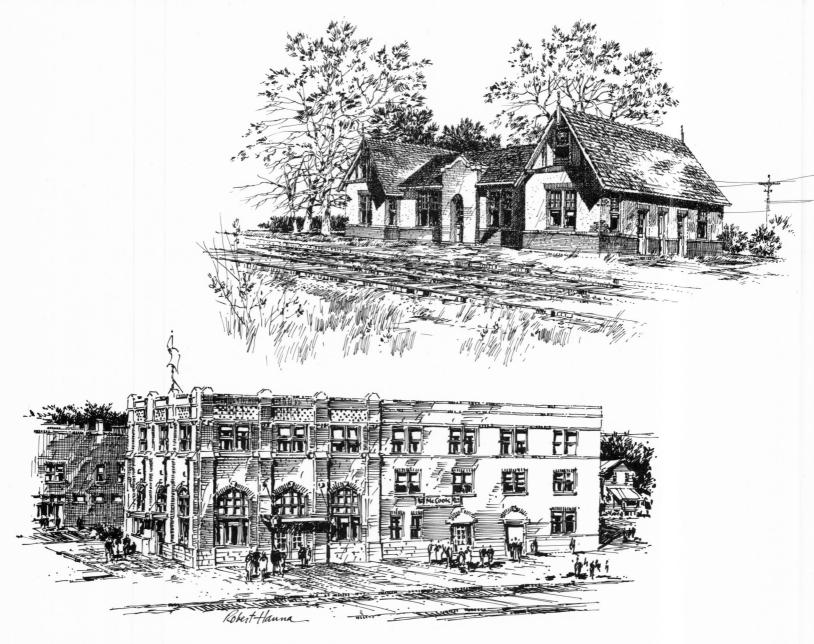

118. Burlington Railroad depot, built 1929, Bridgeport.

119. Burlington Railroad Depot, built 1925–26, McCook.

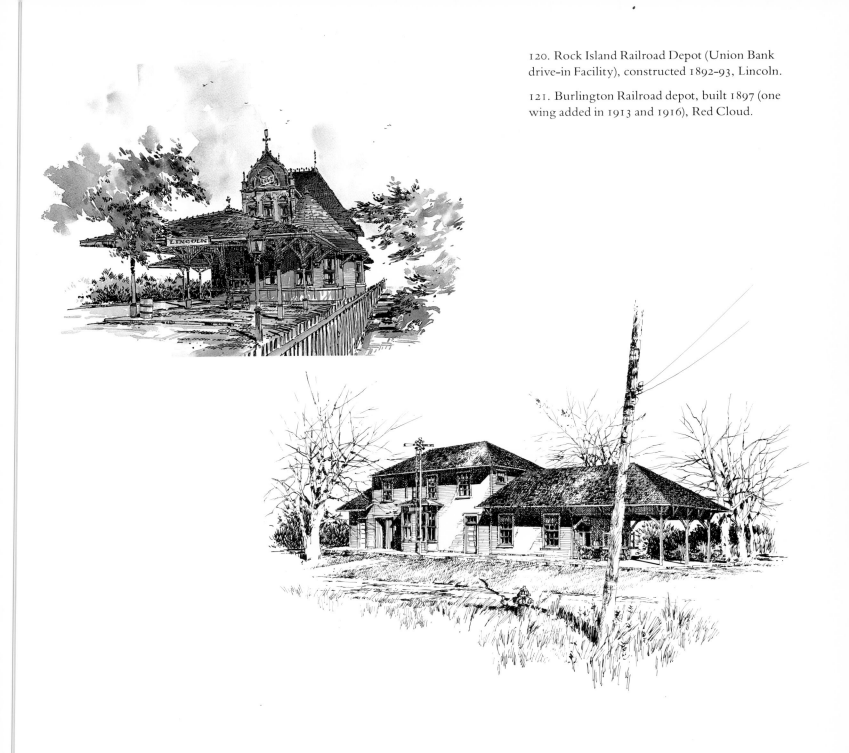

120. Rock Island Railroad Depot (Union Bank drive-in Facility), constructed 1892–93, Lincoln.

121. Burlington Railroad depot, built 1897 (one wing added in 1913 and 1916), Red Cloud.

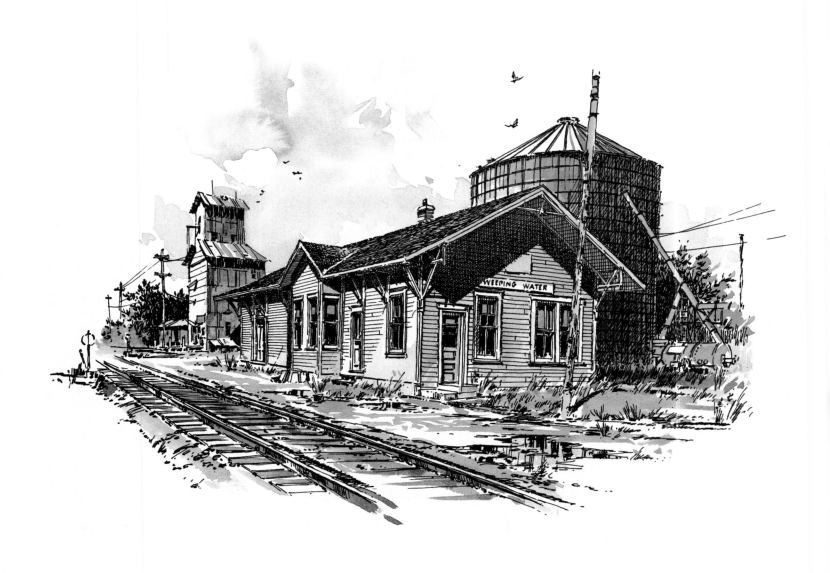

122. Union Pacific Railroad Depot, built 1881, closed 1992, Weeping Water.

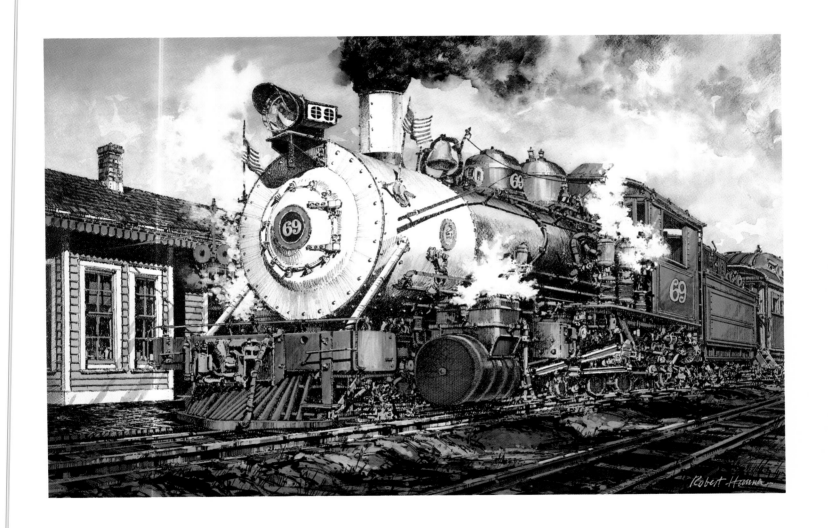

123. Old No. 69, The Stuhr Museum of the Prairie Pioneer, Grand Island.

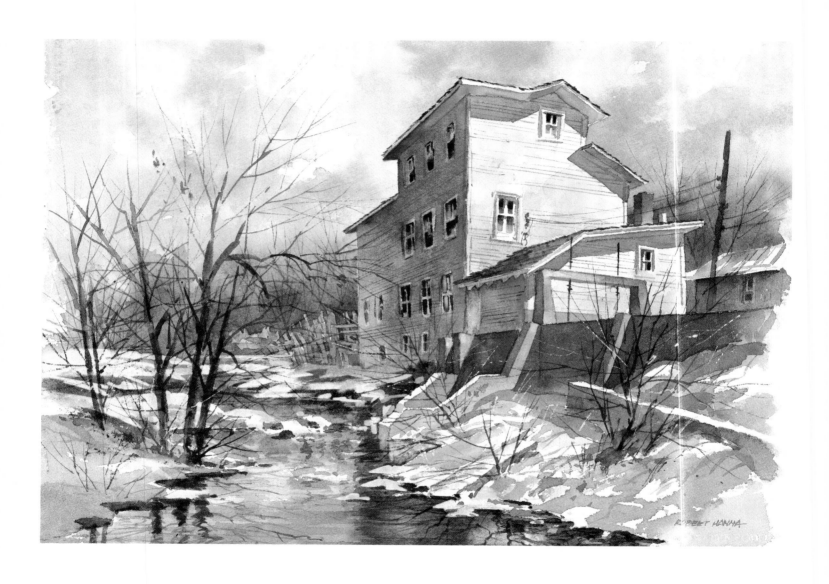

124. The Champion Mill, constructed 1892 on the Frenchman River, Champion.

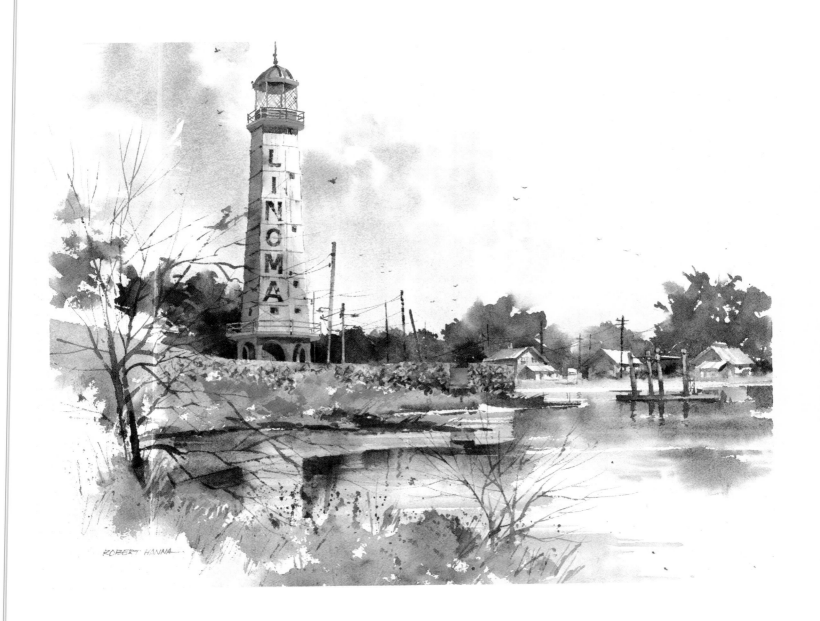

125. Linoma Beach Lighthouse at Linoma Beach, built 1938 on Highway 6 near Ashland.

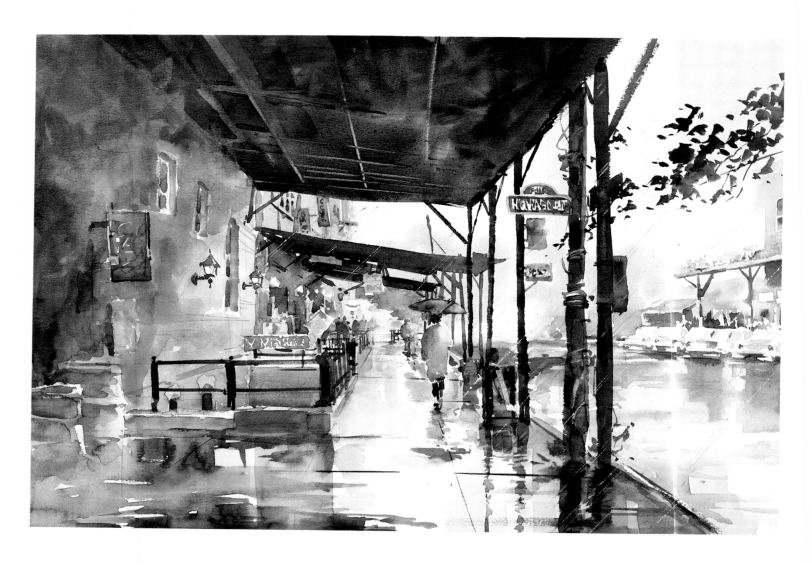

126. The Old Market District, Omaha.

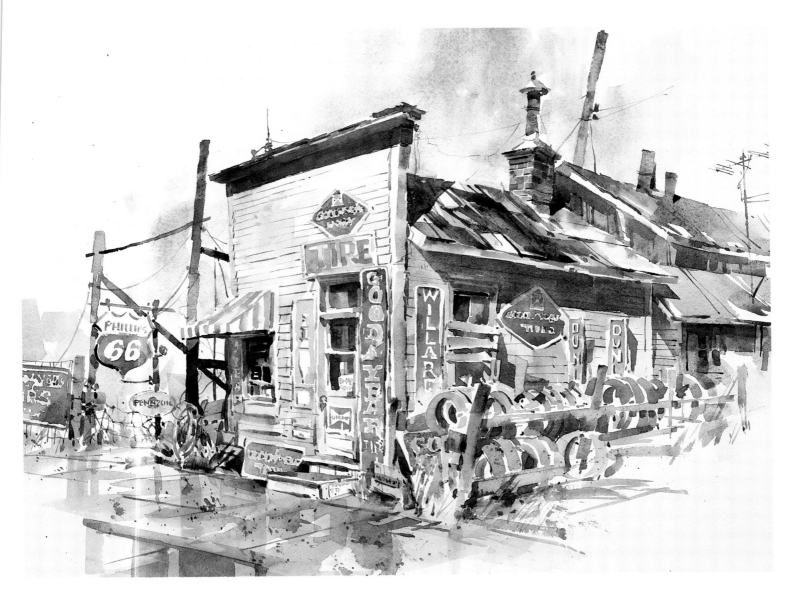

127. Phil's Tire Shop, operated by Phil Connaughton since 1926, Pender.

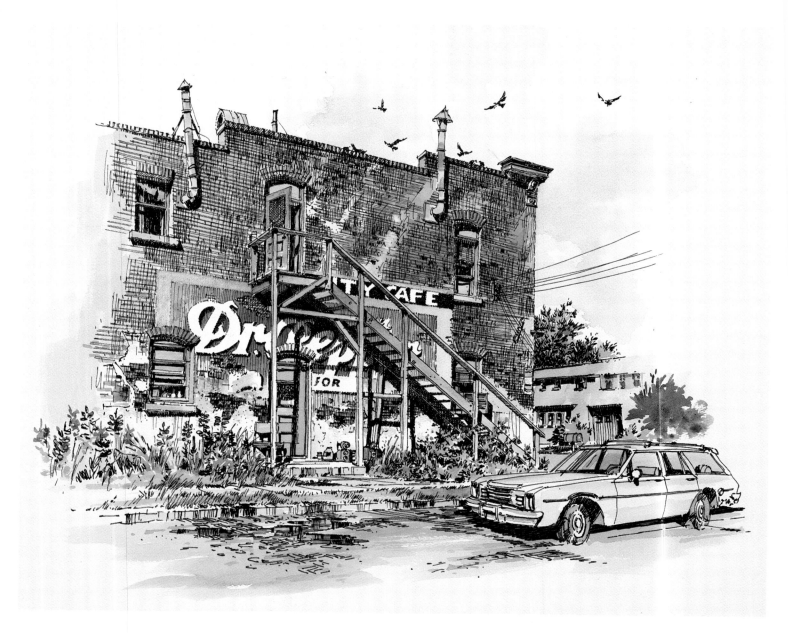

128. Dr. Pepper Sign and City Café, Jackson.

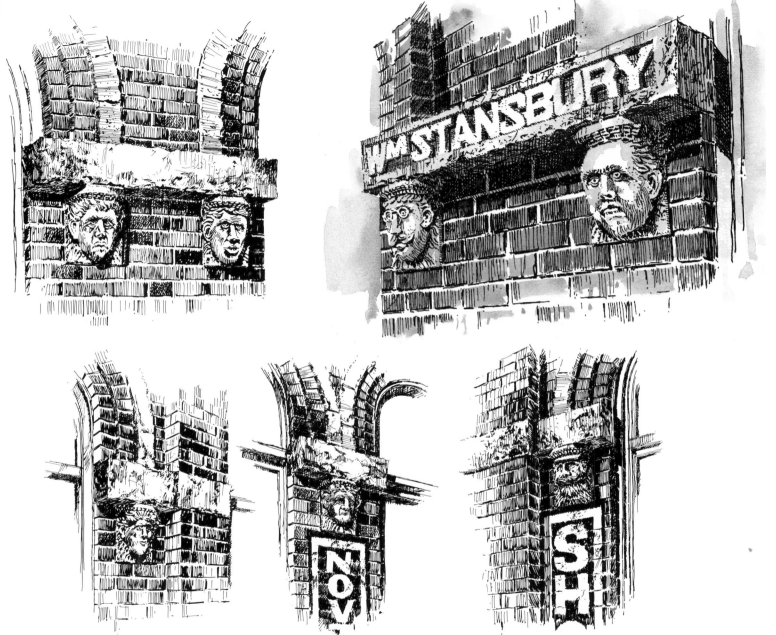

129. Sculpture faces in stone, carved 1899, Nelson.

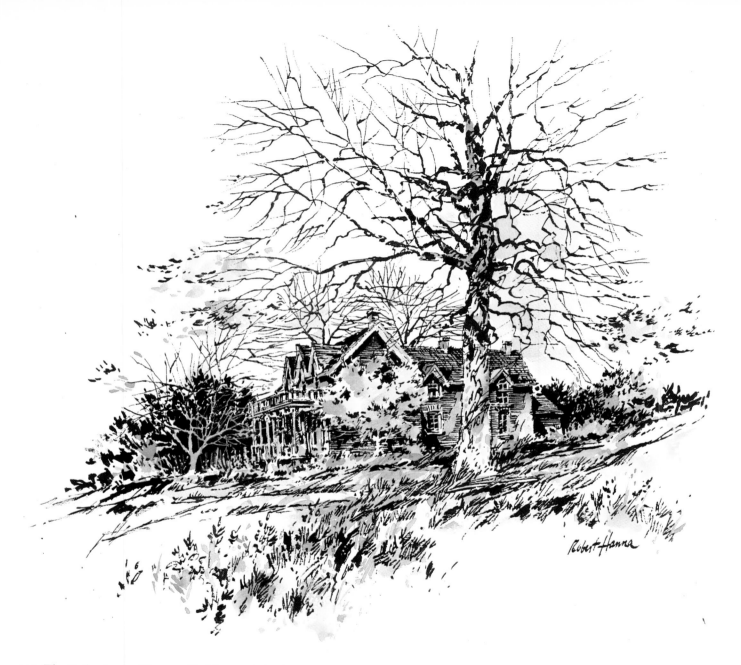

130. The Bailey house (Brownville Museum), built 1877, Brownville.

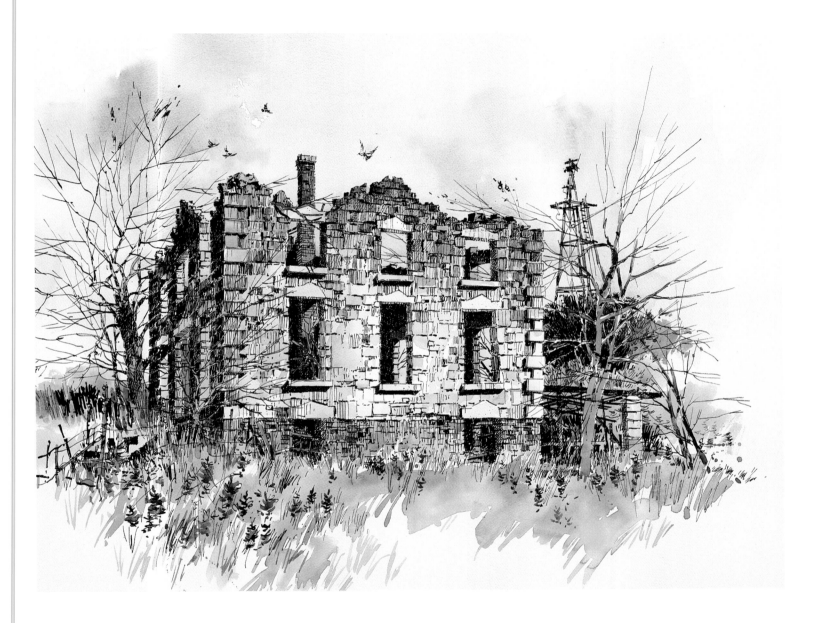

131. Ruins of stone house near Mahoney State Park, Sarpy County.

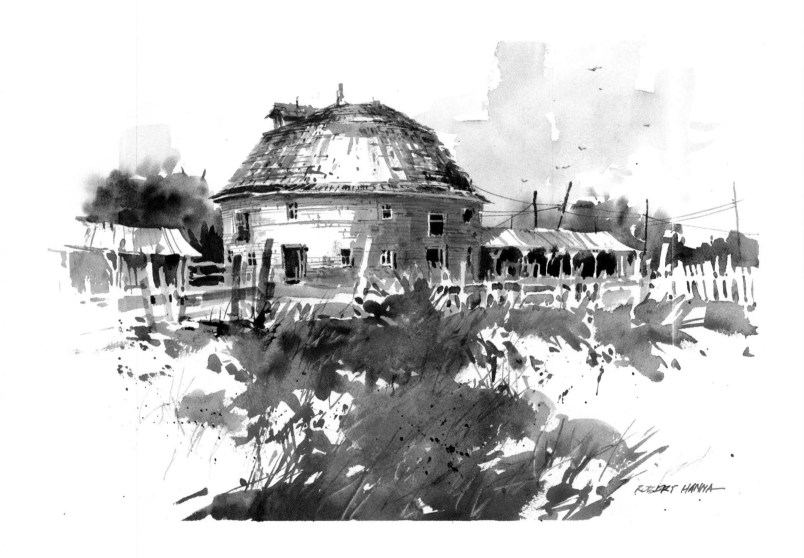

132. Radford round barn, built 1917, on Highway 10 near Minden.

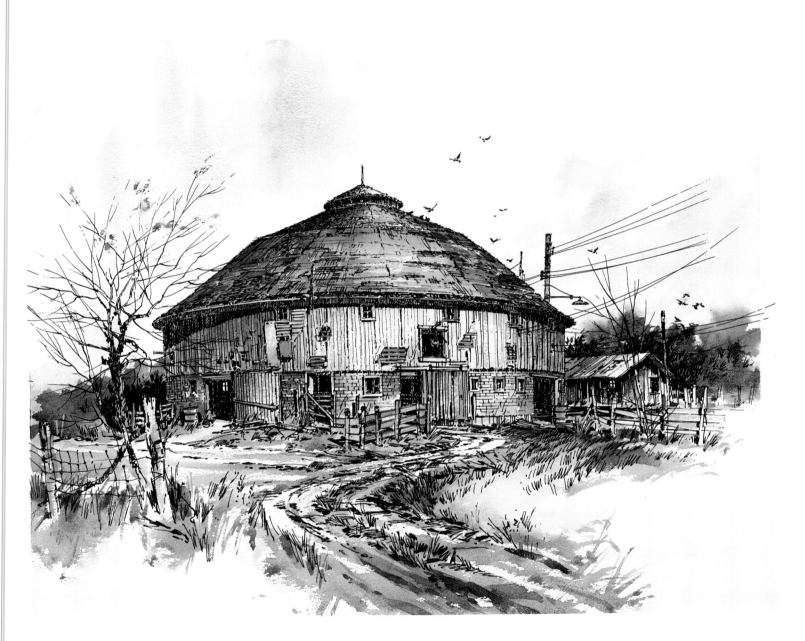

133. Harvey Ehlers round barn, built 1922–24, near Bennett.

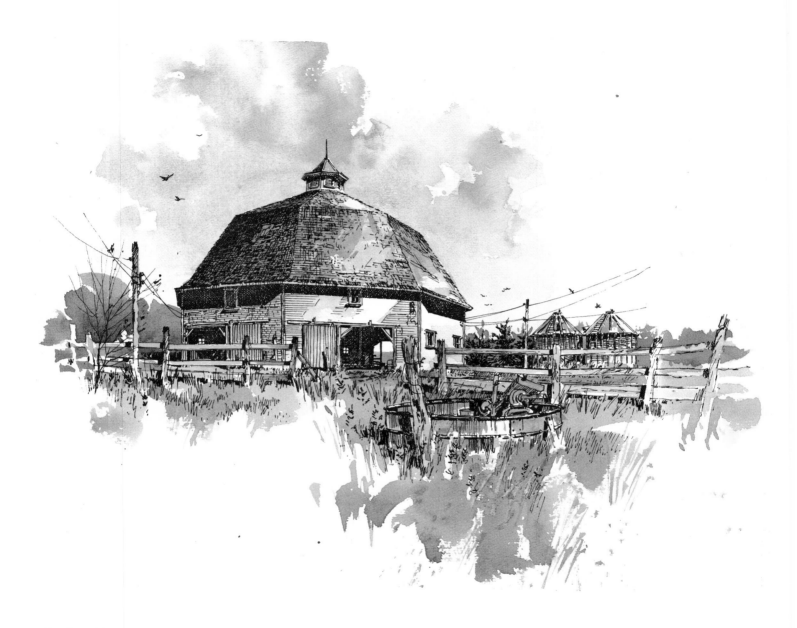

134. Frank Uehling barn, built 1918, on Highway 77, Uehling.

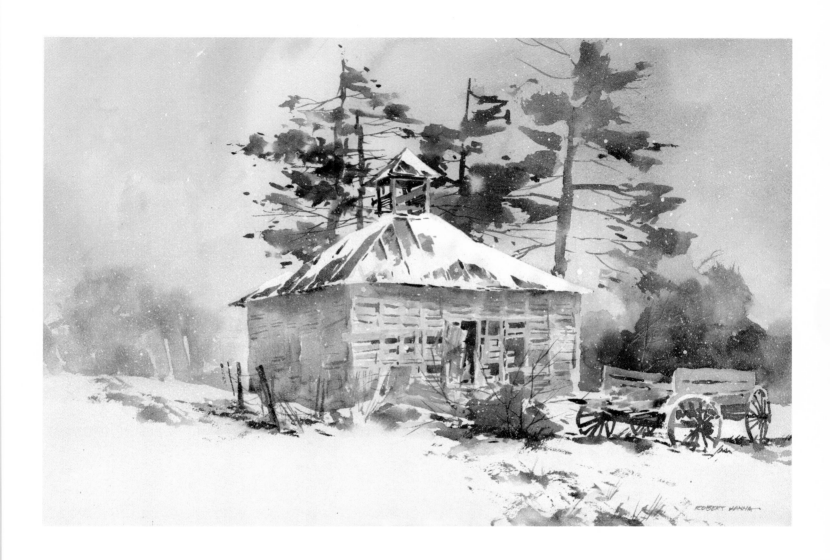

136. Cass County granary near I-80 and the Platte River.

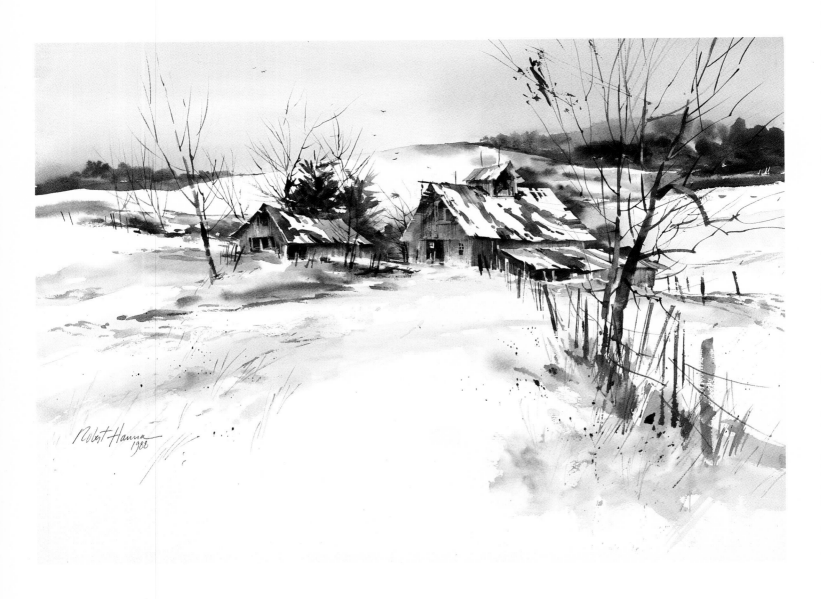

135. Winter, Antelope County.

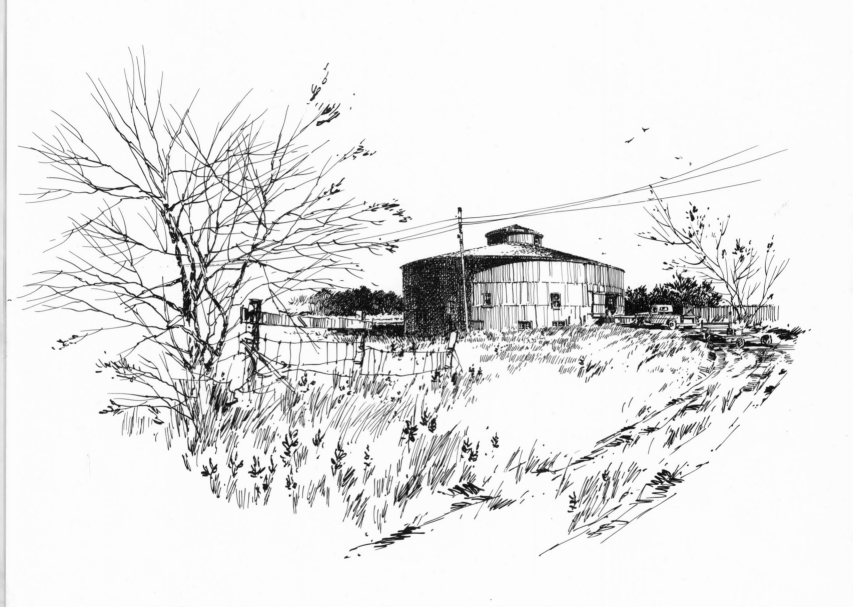

137. Starke round barn, Nebraska's largest barn, built 1902-3, near Red Cloud.

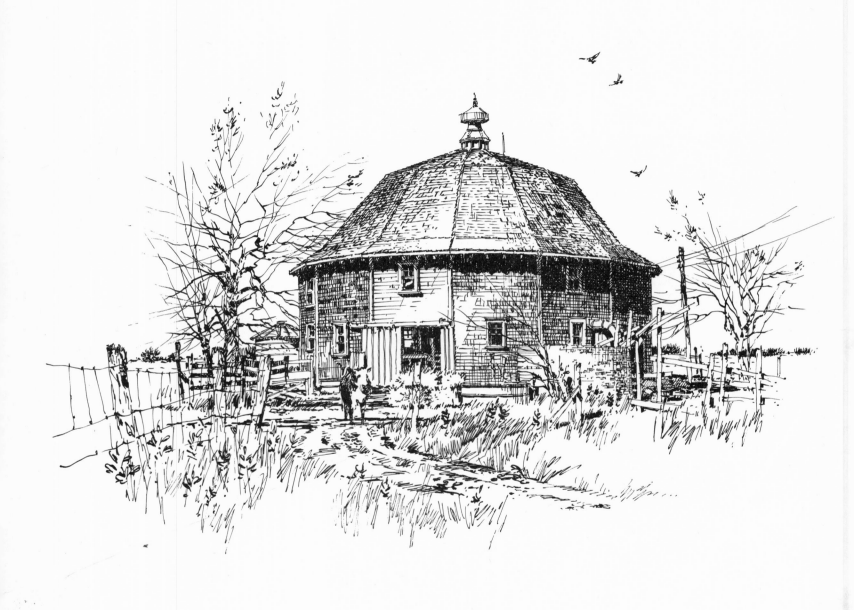

138. Round barn southwest of David City.

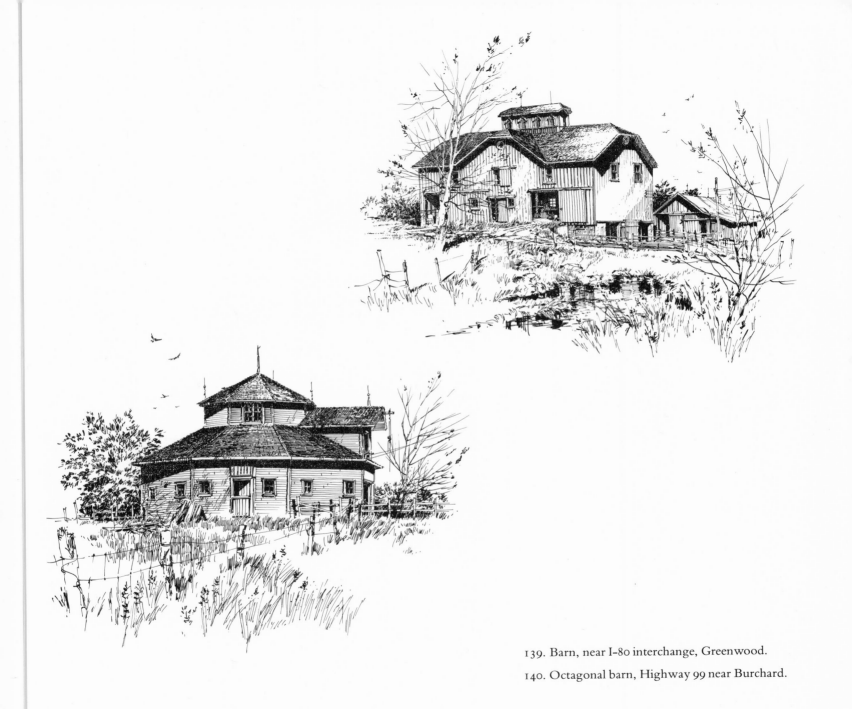

139. Barn, near I-80 interchange, Greenwood.

140. Octagonal barn, Highway 99 near Burchard.

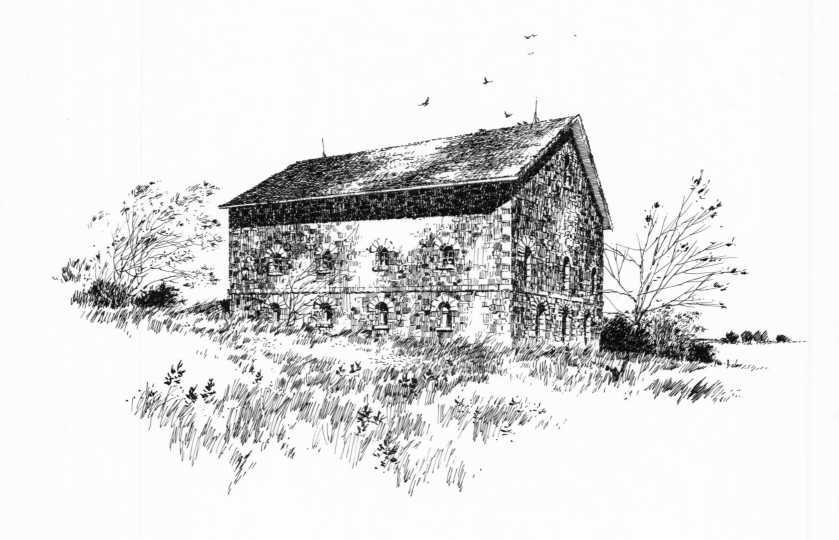

141. Elijah Filley stone barn, built 1874, near Filly.

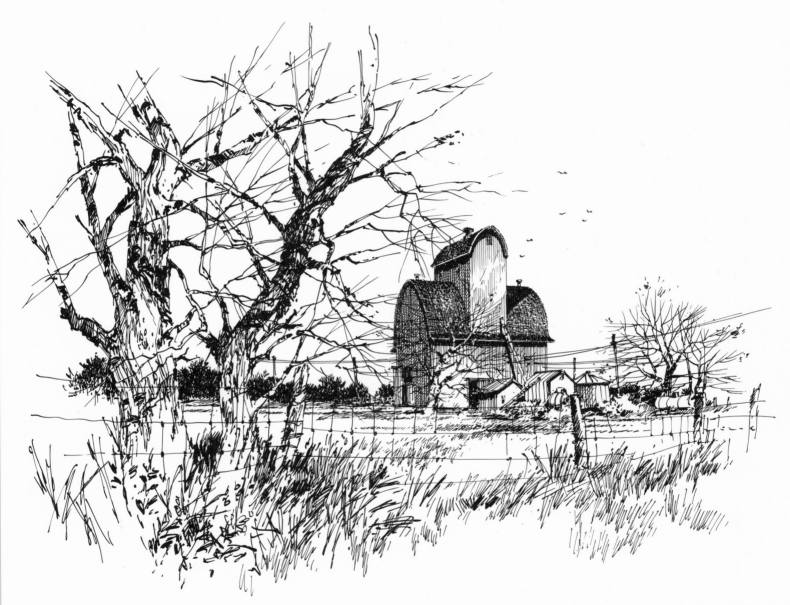

142. John Caveny Grain Elevator, 100 foot high, built by Gus Olson in 1954, near Wood River.

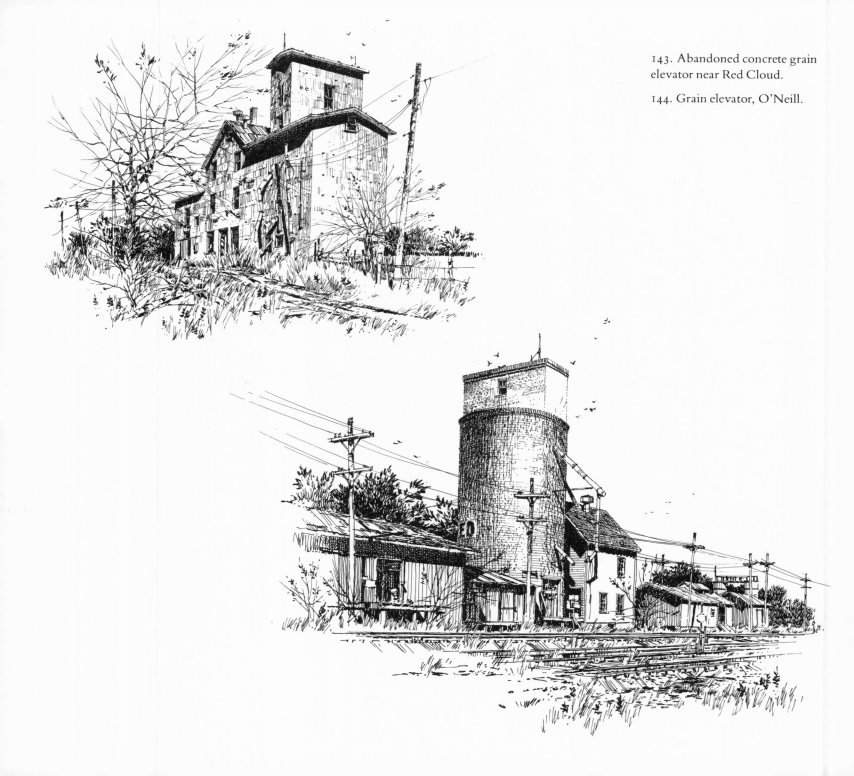

143. Abandoned concrete grain elevator near Red Cloud.

144. Grain elevator, O'Neill.

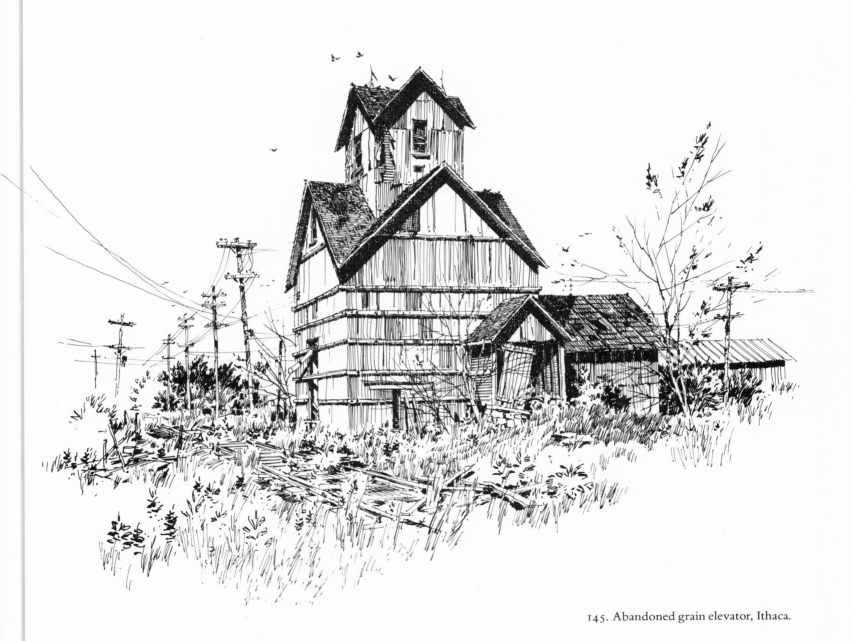

145. Abandoned grain elevator, Ithaca.

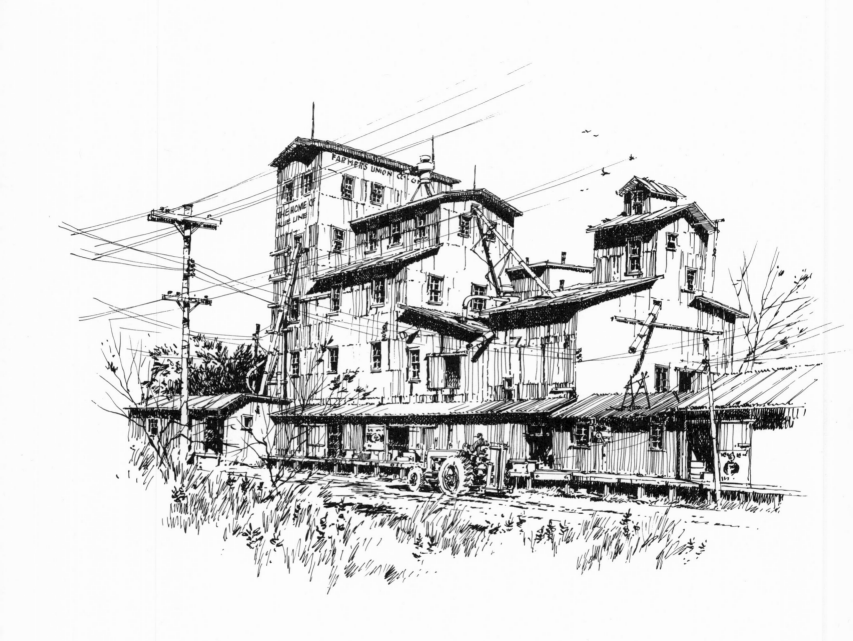

146. Old Scolar Grain Company, Superior.

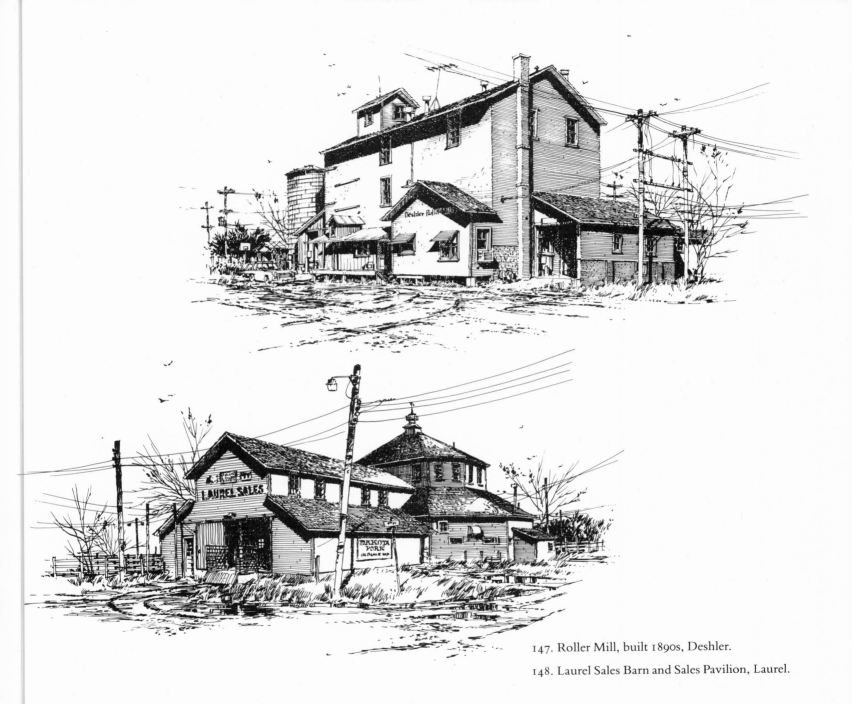

147. Roller Mill, built 1890s, Deshler.

148. Laurel Sales Barn and Sales Pavilion, Laurel.

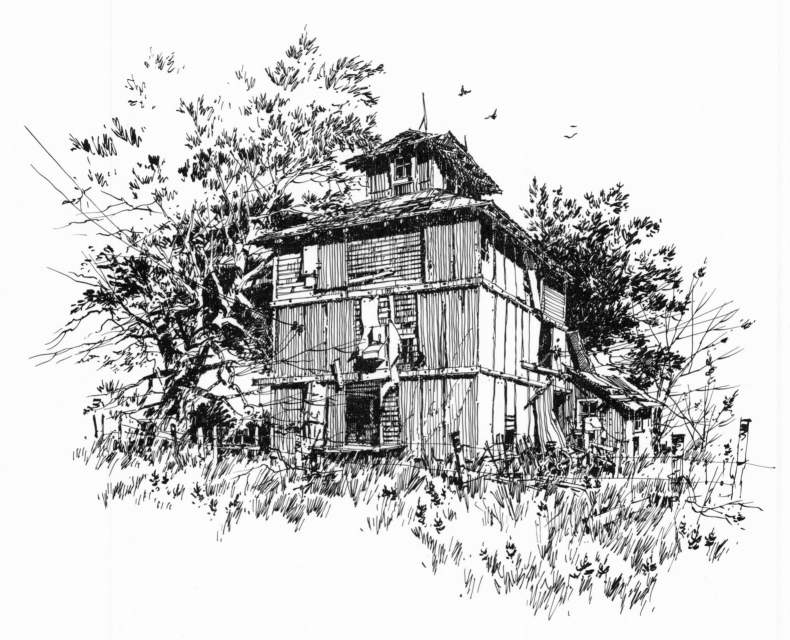

149. Abandoned elevator, Comstock.

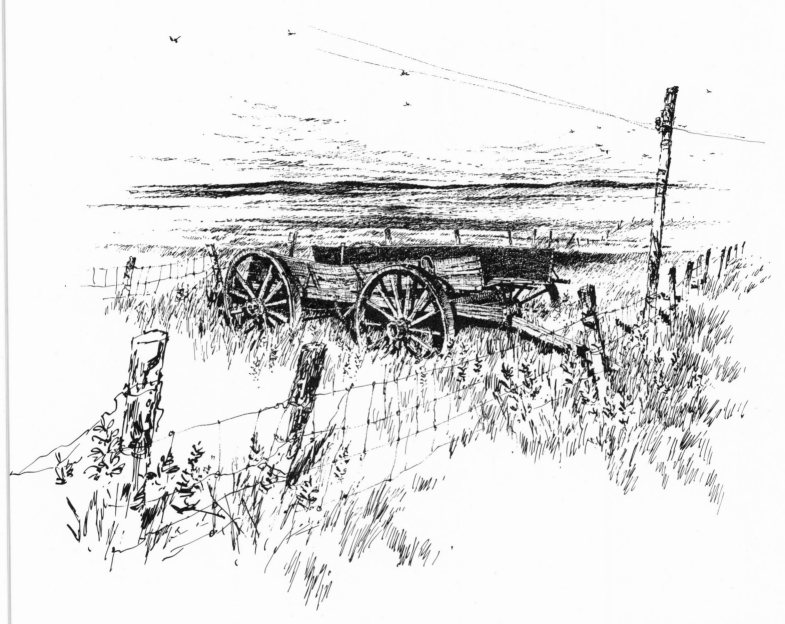

150. Along Highway 61 between Hyannis and Arthur.

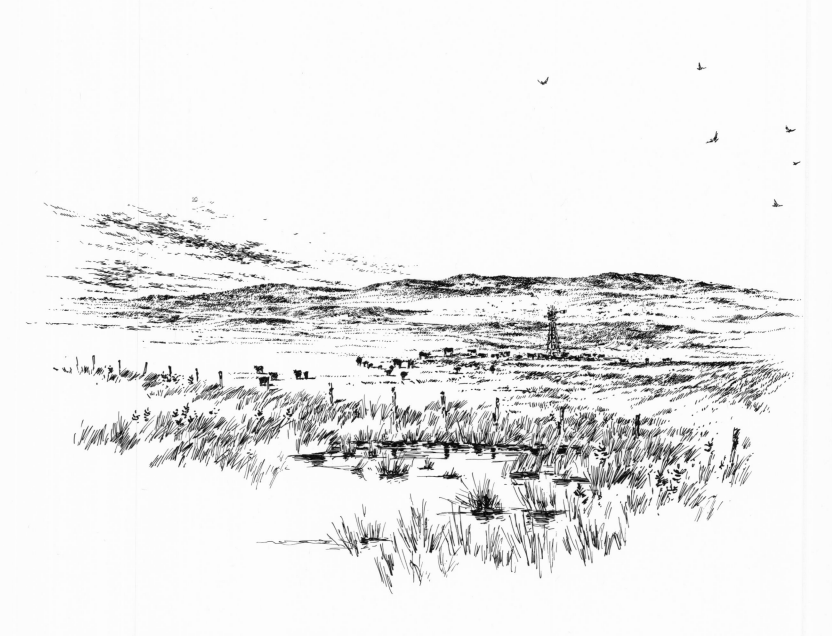

151. Prairie view on Highway 2 near Antioch, Sheridan County.

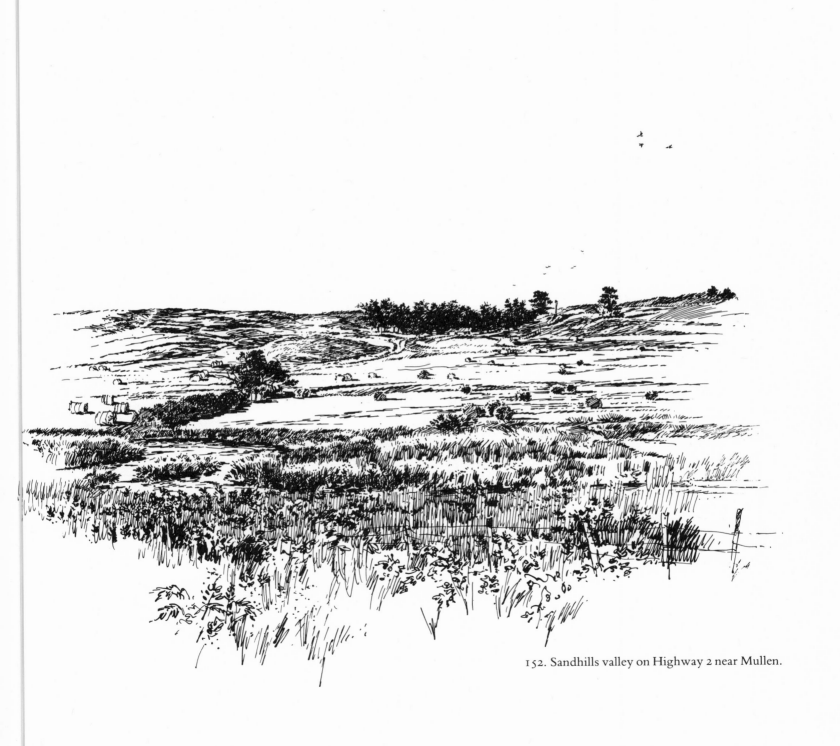

152. Sandhills valley on Highway 2 near Mullen.

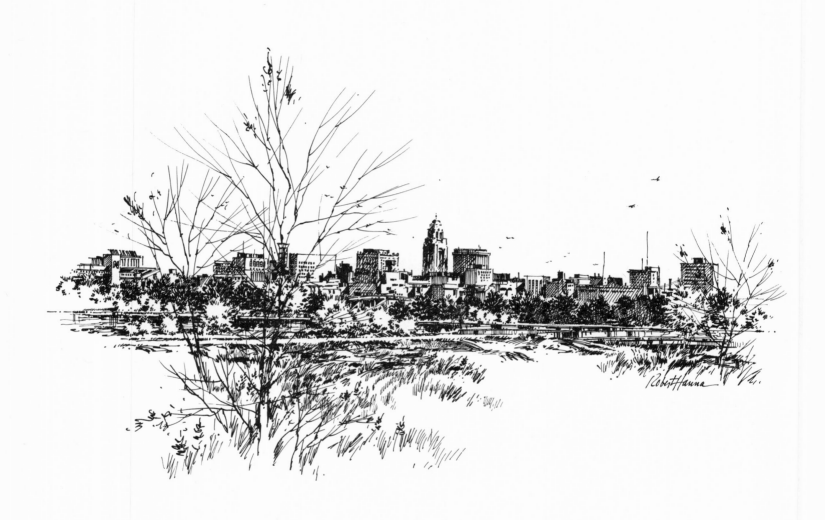

153. View of Nebraska's capital city from northwest Highway 34, Lincoln.

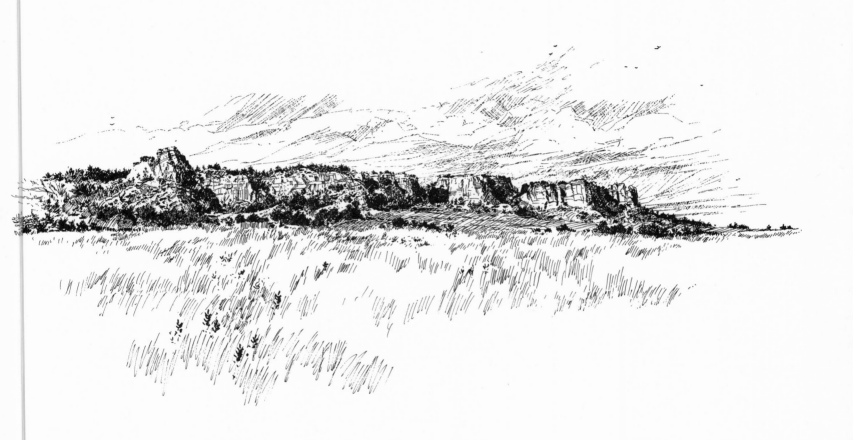

154. Buttes southwest of Crawford, 1991.

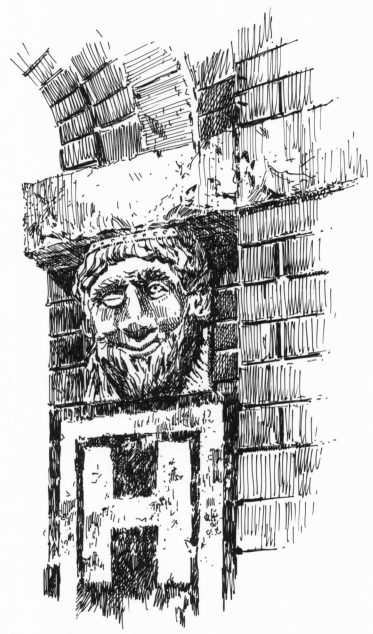

155. Stone face with winking eye, carved 1899, Nelson.